IMAGES
of America

NAPA

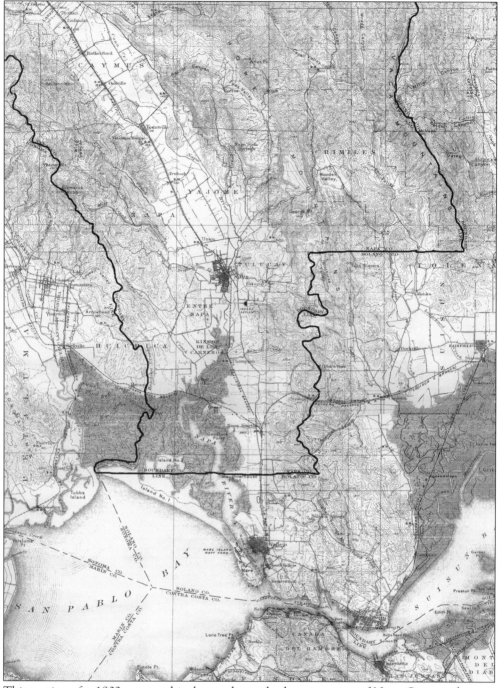

This section of a 1902 topographical map shows the lower portion of Napa County, the area covered in this book. Berryessa valley is beyond the upper right corner, to the northeast.

IMAGES
of America

NAPA

The Napa Valley Museum
and Lin Weber

ARCADIA

Published by Arcadia Publishing
Charleston SC, Chicago IL, Portsmouth NH, San Francisco CA

Printed in Great Britain

Library of Congress Catalog Card Number: 2004110657

For all general information contact Arcadia Publishing at:
Telephone 843-853-2070
Fax 843-853-0044
E-mail sales@arcadiapublishing.com
For customer service and orders:
Toll-Free 1-888-313-2665

Visit us on the internet at http://www.arcadiapublishing.com

CONTENTS

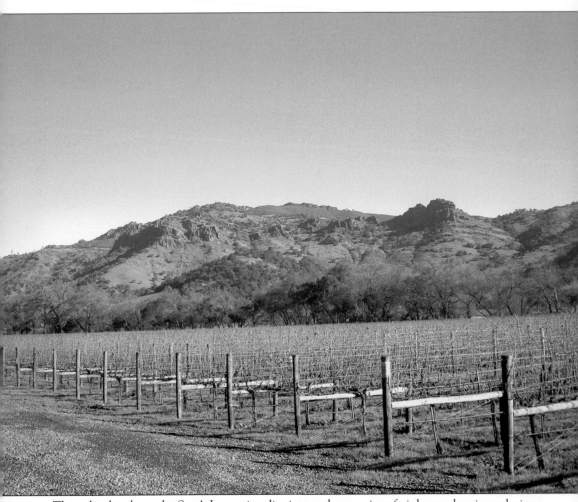

The palisades above the Stag's Leap wine district are the remains of violent volcanic explosions. Pressure beneath the surface built up to such an extent that lava burst forth in spectacular "plinian" eruptions, spewing hot, billowing clouds of gas and ash for miles. A thick layer of ash lies well beneath this vineyard at Stag's Leap Wine Cellars. Volcanism has produced a *terroir* perfectly suited to growing premium wine grapes.

INTRODUCTION

Change has often been a difficult process for the Napa Valley. One of the most significant changes shaping the region's unique geography was the movement of three enormous geological (tectonic) plates, which had been inching their way up the coast for millions of years. The area where these three plates joined was prone to violent geologic activity: earthquakes, rising magma, and peppering from actual volcanoes, where magma erupted through the surface and spilled out as lava. About 6 million years ago, this moving triple juncture passed directly under the Napa Valley, giving rise to the Sonoma Volcanics, intrusive and sometimes explosive upwellings located on both sides of the valley. The massive formation of basalt just south of the city of Napa is one remnant of that era. The palisades above the Stag's Leap District near the Yountville/Napa border are another, and there are many more.

Horrific as it was, the age of volcanoes ultimately benefited the Napa Valley. Volcanism was responsible for the creation of deposits of marketable metals like mercury and silver, and architects of the 19th century used volcanic rock to construct fine buildings and bridges. The dramatic beauty of the terrain and the presence of hot and mineral-rich springs have drawn tourists. Most importantly, the lava and volcanic ash broke down to form soil ideal for growing wine grapes. The resulting wine industry has brought the valley fame and great wealth.

Human beings first came to the Napa Valley at least 6,000 years ago. Ancient spear points and arrowheads of various sizes and shapes are evidence of successions of early peoples passing through or making this place their home. A group known today as the Wappo populated the general region, but fell victim to change when other ancient peoples began to migrate into the area. One, the Wintun, encroached on the Wappos' southern hunting places and made permanent encampments around what is now the city of Napa. The Wappo withdrew to the north, unhappy and disposed to battle.

Change would come again in 1823, when soldiers of the newly created country of Mexico entered the valley from the southwest to explore the lands they had inherited when they broke away from Spain. They saw great herds of elk and a fearsome number of bears, but the Wintun hid from them. The natives could not hide, however, from the diseases that traveled with the Europeans. In less than a generation, most of these Native Americans—Wintun and Wappo alike—had perished or were forcibly relocated.

Under General Mariano Vallejo, the Mexicans formed a small pueblo and ran cattle in southern Napa Valley, but they, too, would be victims of change, for Americans had started to find their way across the High Sierras. An American mountain man named George Yount

received a grant of land in what would become Yountville, near the Wappo/Wintun boundary. Other Americans would follow, lured by the glint of gold.

Gold Rush–era merchants helped to establish Napa City on the banks of the Napa River. The little waterway provided the developing valley with easy access to San Francisco's ports and markets. While farmers in the Up Valley (the region above Yountville) were experimenting with viticulture, Napans were founding businesses and small manufacturing companies.

The general economy underwent a downturn at the start of the 20th century. Many of Napa's original enterprises closed and its pioneer families moved away, selling out to recently arrived Italian immigrants who savored the chance for a new beginning.

Prohibition and the Great Depression produced more difficult changes. Long after many parts of the United States had rebounded, the cities of Napa and Yountville had difficulty thriving. Lacking significant political clout, local representatives were unable to stop the U.S. Bureau of Reclamation from flooding one of the county's jewels, Berryessa Valley, to provide water for neighboring Yolo and Solano Counties, a project that was completed in 1957.

Southern Napa Valley was late in embracing the wine industry and its cultural allure. In recent years, however, the hillsides in this former cattle-grazing area have begun to grow green with grapes. Land values have risen dramatically since the 1990s. Glad to find attractive acreage near California's main transportation arteries while still removed from the San Francisco Bay Area's urban bustle, moneyed newcomers are plunking down top dollar for a piece of what is now considered the South County "wine country."

Napa, Yountville, and the newly incorporated city of American Canyon hope to capitalize on this influx of new families. Attractions like the Napa Valley Museum, Copia, and the Napa Valley Opera House offer high-quality cultural experiences; excellent restaurants have proliferated, and an ambitious flood-control project is underway. While high-volume, big-box stores like Target and Home Depot are now thriving around the city's periphery, commercial investors in Napa's downtown area plan to revitalize with upscale businesses, ushering in, they hope, yet another era of change.

This book, written by award-winning historian Lin Weber, illustrates the changes that the Napa area has seen since earliest times. Most of the photographs come from the Napa Valley Museum's archives, but many have been loaned to us for this project by private collectors, the Napa County Historical Society, the Napa Economic Redevelopment Office, the Bureau of Reclamation, the Napa River Inn, and other sources, to whom we are very grateful.

—Eric Nelson, Executive Director
Napa Valley Museum

One
ALL BUT VANISHED

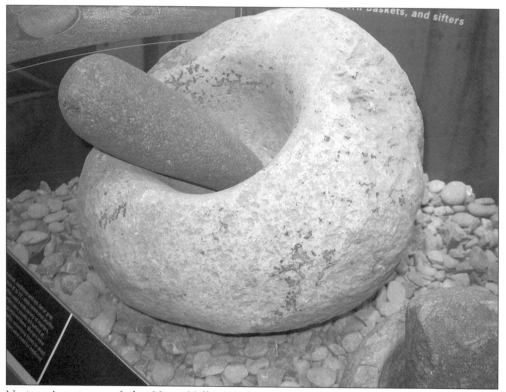

Native Americans of the Napa Valley used mortars and pestles to grind acorns, which were the mainstay of their diet. The Napa Valley Museum has a large collection of these grinding objects.

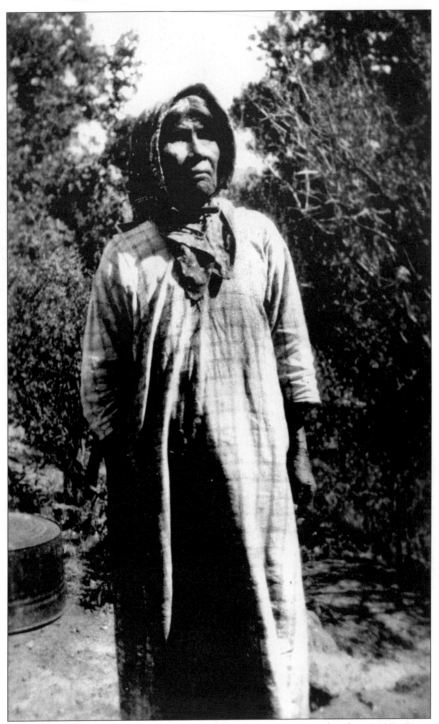

C. Hart Merriam photographed this Wintun woman in a Napa orchard in 1927. Some 2,500 Wintun descendants live in Northern California today. The Wintun arrived in the Napa Valley long after the Wappo had established seasonal hunting camps here. The two peoples spoke entirely different languages and engaged in occasional skirmishes with each other.

The Mexican government sent Mariano Vallejo to oversee the development of the area. Vallejo complained to the governor that the policy of forcing the natives to accept Christianity had created considerable hostility. To help secure the area for Mexico, he issued grants of land to family members and other persons of rank, including a few Americans who agreed to become Mexican citizens and convert to Catholicism. (Courtesy of the *Sonoma Index-Tribune*.)

Salvador Vallejo, Mariano's brother, led well-armed soldiers in several major battles against the Indians. He ran cattle on his Napa (also known as "Trancas") rancho and acquired the neighboring Yajome grant. (Courtesy of the *Sonoma Index-Tribune*.)

One of the soldiers under General Mariano and Salvador Vallejo's command was Don Cayetano Juarez (left), whose Indian-fighting armor consisted of seven layers of rawhide. Wounded at least three times in battle, he was honorably discharged in 1836. Later he brought horses and cattle to the Napa Valley, tending them by day before returning at night to his home in Sonoma. Vallejo rewarded him for his loyal service with a grant of more than 8,800 acres bounded on the west by the Napa River and the east by the Vaca Mountains. Don Cayetano named it "Tulucay," probably after a Wintun/Patwin encampment there. (Courtesy of the Napa County Historical Society.)

The crumbling structure on the right is Don Cayetano's original adobe; the one on the left is its replacement, which still stands on Soscol Avenue and has been a restaurant since the early 20th century or earlier. The Juarez family hosted rodeos at the old adobe. Native peoples continued to live at the site for many years despite the intrusion of buildings, horses, and people.

Cattle like these in this crude corral were the focus of life during the short span between 1830 and 1846, part of an era often called the "Mexican pastoral period." Rich men owned the land and the animals. Poor men worked them all day long, and the wives of both served beef at most meals. Cow hides were the most significant items traded in what would become Napa County, and even after Mexico lost California to the United States at the end of the Mexican-American War in 1848, tanning and leather-working businesses continued to be important local employers. Oats, sown through livestock droppings, quickly overtook the native bunch grasses and grew high in the fertile soil.

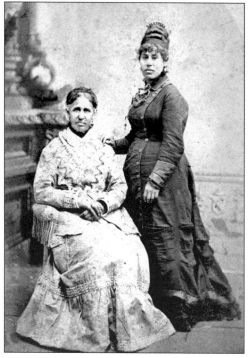

Don Cayetano's wife, Maria Higuera Juarez (seated), was the daughter of a soldier who marched with Captain Bautista de Anza in the expedition that founded San Francisco. She and Don Cayetano were married at Mission Dolores in 1835. They had 11 children, most of whom married American pioneers. (Courtesy of the Napa County Historical Society.)

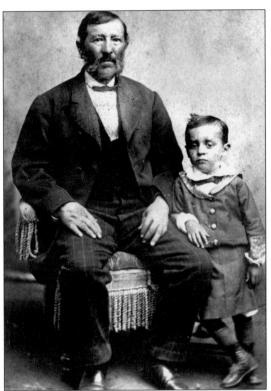

Cayetano Juarez, seen here with his grandson, Roy Lolito Juarez, was popular with the Americans who made Napa City their home. Juarez Street was named for him.

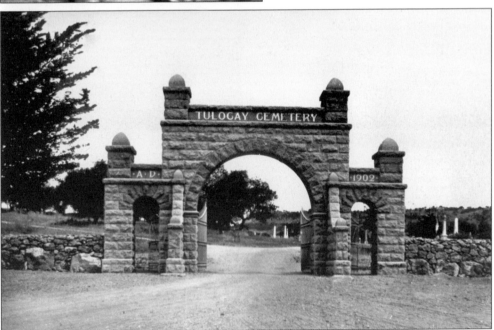

When Napa City's newly formed Cemetery Association approached Don Cayetano in 1858 to purchase some of his land for the purpose of interring Napa's deceased, the don refused to sell. Instead, he gave the land, cost free—almost 50 acres of it. A local stonemason built this fine triple-arch entranceway in 1902. Juarez himself was put to rest there in 1883.

Two
PIONEERS: A SAMPLER

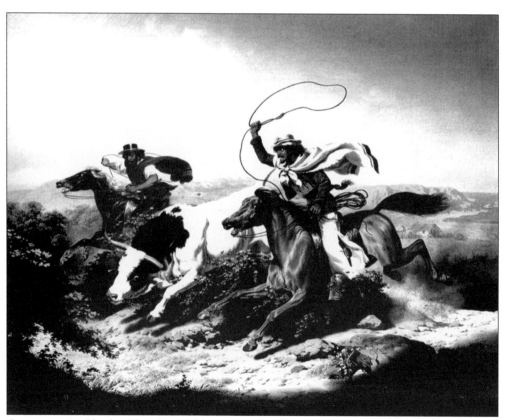

German artist Charles Christian Nahl came to the West to mine for gold, but gave California more than he took from it—Nahl designed the grizzly bear on the state flag. His oil paintings of western life captured the essence of the Mexican pastoral period, although technically that era had already ended when he arrived in America in 1848. *Vaqueros Roping a Steer*, above, is reprinted by permission of the Anschutz Collection.

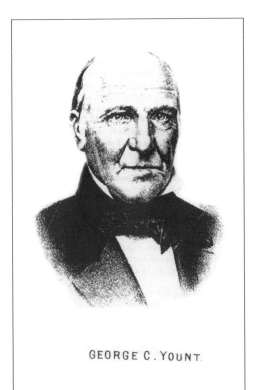

GEORGE C. YOUNT.

Mountain man George Yount traded in his buckskins in 1836 to become the first person of European descent to own land and live in the Napa Valley. Wary at first of the natives who populated his 12,000 acres, he built a small wooden fortress and slept with his gun at the ready. A smallpox epidemic struck the region and decimated the natives, to whom Yount was sometimes friend and sometimes foe. In later years, American squatters built cabins on his Caymus Rancho (the name of the former Wappo settlement there). His wife helped him through years of tedious litigation to keep the squatters off his land. George Yount named the town that evolved around him "Sebastopol," but in 1869 his fellow citizens renamed it "Yountville" in his honor.

George Yount's daughter, Elizabeth (right), came to the Napa Valley with her sister, Frances, and Frances's husband, Bartlett Vines, in 1843. Joe Chiles, another Napa pioneer, helped lead the way, and the overland party consisted of a number of people who would live in Napa County. Elizabeth married John Calvert Davis, a builder of boats and barges whose vessels were among the first to navigate the Napa River and the estuaries of San Pablo Bay. Davis sailed one of his ships all the way to Mazatlan and back. After Davis died, Elizabeth married Eugene L. Sullivan, who was a customs collector of the Port of San Francisco and a state senator. (Courtesy of Toni Porterfield.)

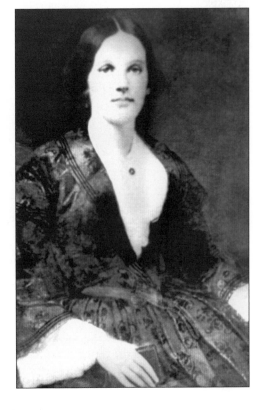

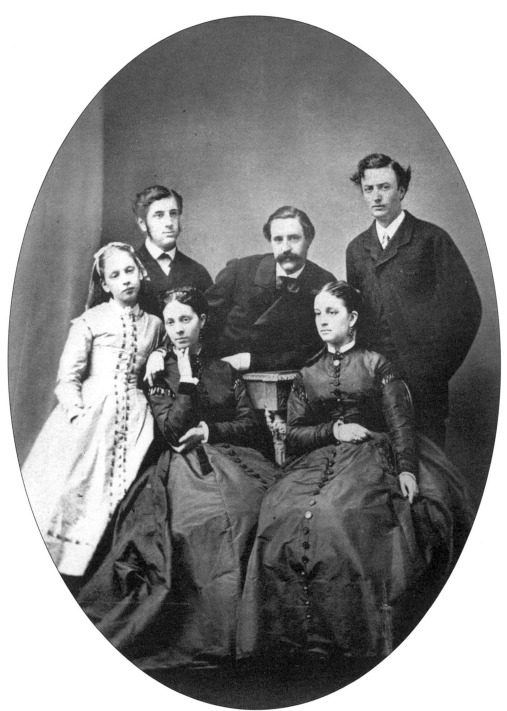

Yount's grandchildren and their spouses pose here, from left to right: (seated) Yount granddaughters Mary Davis Bucknall and Elizabeth Davis Watson; (standing) granddaughter Georgie Sullivan, grandson John Davis, William Campbell Watson, and Dr. George Bucknall. Another granddaughter, Elizabeth Yount, married Thomas Rutherford, for whom the town of Rutherford is named. (Courtesy of Toni Porterfield.)

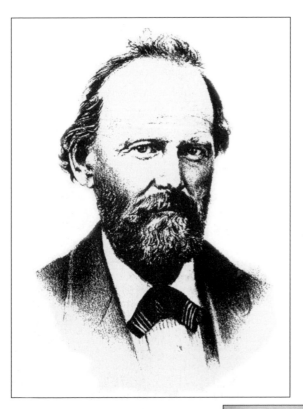

Massachusetts-born Nathan Coombs first tried settling in Oregon but didn't like the rainy weather. In 1843 he came to California, then under Mexican rule, secured a passport, and lived near what is now Woodland. While there, he was almost killed when a grizzly yanked him off his horse. Seeking an environment with more people and fewer bears, he made his way to the tiny pueblo that is now Napa, purchasing land from both Salvador Vallejo and Nicolas Higuera. "Napa" may have been a campsite of the "Napato," one of the Wintun sub-groups the Mexican soldiers brought to the Sonoma mission. (Sketch taken from Lyman Palmer's *History of Napa and Lake Counties California*, Slocum & Bowen Co., Publishers, San Francisco, 1881.)

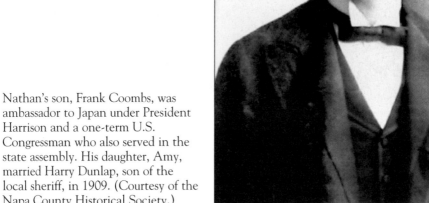

Nathan's son, Frank Coombs, was ambassador to Japan under President Harrison and a one-term U.S. Congressman who also served in the state assembly. His daughter, Amy, married Harry Dunlap, son of the local sheriff, in 1909. (Courtesy of the Napa County Historical Society.)

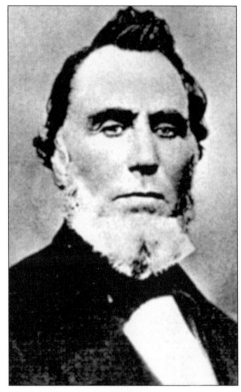

John Grigsby stares grimly at the camera in a worn photo taken long ago. Grigsby came to the Napa Valley in 1845 as a member of a wagon-train party that included several others who would also make the valley their home. The Mexican government protested the arrival of undocumented foreigners like Grigsby and his fellow travelers. Fearful that they would be forced to leave, the recently arrived Americans banded together and stormed the home of Mariano Vallejo in Sonoma. They also took over the garrison, with the help of John C. Fremont. The 1846 incident and the skirmishes that followed—known as the "Bear Flag Revolt" for the odd, homemade flag they flew after taking the fort—brought California into the Mexican-American War, which was already being waged in Texas. Grigsby came to the pueblo at Napa and did some work for Nicolas Higuera, who paid him with a strip of land by the river. Nathan Coombs and John Grigsby swapped plots, and Coombs immediately laid out plans for building a town. He wanted to call it "Coombsville," but the name didn't stick. (Courtesy of Robert D. Parmelee.)

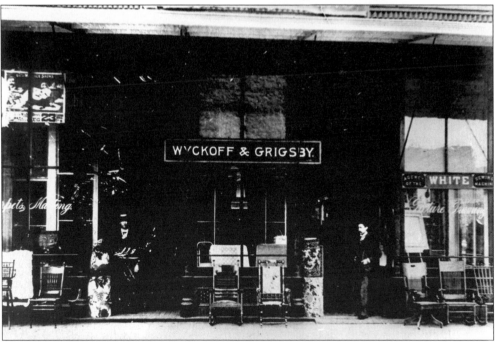

John Grigsby left the area, but his brothers, nieces, and nephews remained and were very active in the community. One of the Grigsbys (right) partnered with a Mr. Wyckoff in a Napa furniture store.

Among the important denizens of earliest Napa were various members of the Boggs family. Lilburn W. Boggs, once governor of Missouri, arrived in California in the autumn of 1846, just ahead of the ill-fated Donner Party. The Stars and Stripes had replaced the Bear Flag at Sonoma, and the Mexican-American War was underway. Because Boggs was a dignitary, the recently liberated General Vallejo offered Boggs and his family lodging in his home. Their son, Albert Gallatin Boggs, seen here, worked for a while in Sonoma and then came to Napa, where he served as county treasurer. (Courtesy of Lorrain Kongsgaard.)

Lucy Evans Boggs was the wife of Albert Gallatin Boggs. (Courtesy of Lorrain Kongsgaard.)

In January 1848 gold was discovered in the Sierras, and nine days later the Mexican-American War ended with the United States the victor and California and the southwest the prize. The builders of the tiny town of Napa (a.k.a Coombsville) dropped their hammers and headed for the hills. Many of the men who panned for gold in the spring of 1848 came back with treasure, and some of them invested in land in Napa County and its county seat, "Napa City." Its dusty streets lined with saloons and small businesses, Napa City became a popular place for miners to spend their earnings. Freedman Levinson, pictured here at right, set up shop in Napa before 1850. He had a small general store on Main Street and kept a canary outside the front entrance to draw customers. Like other merchants of his day, he became adept at telling real gold from fake. (Courtesy of Claire Erks.)

Quite a few of Napa Valley's earliest merchants were, like the Levinsons, Jewish. Here several merchants' daughters, some Jewish and some Gentile, gather for a group portrait. The pendants they wear are gifts from their beaux. Shown, from left to right, are: (front row) Amelia Kather and Clara Levinson; (middle row) Minnie Schwartz and Gussie Kather; (back row) Sarah Levinson, Bertha Engle, and Lilly Griffith. (Courtesy of Claire Erks.)

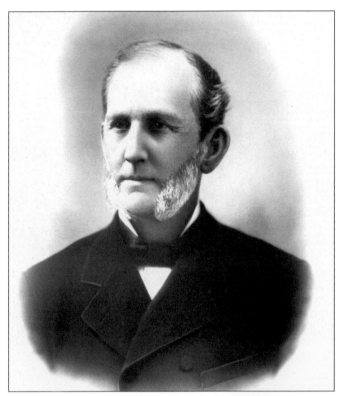

George Goodman (left) and his brother, James, were among those who profited from the Gold Rush. The Goodmans came to San Francisco in 1852 and started a small chain of grocery stores that made so much money they eventually opened a bank in Napa at the site of one of their stores. James H. Goodman & Company was the only bank in Napa from the day it opened its doors in 1858 to October 1871, when the Bank of Napa began operations. George served as county treasurer from 1861 to 1870, preceding A.G. Boggs. (Courtesy of the Napa County Historical Society.)

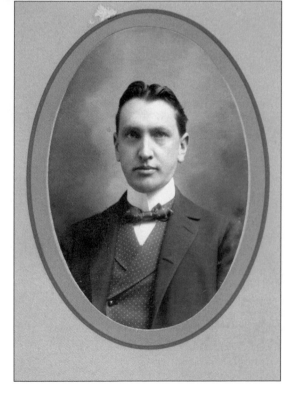

George Goodman's son, Harvey, was president of the First National Bank of Napa and became chairman of the board in 1921 when this photo was taken. First National's vault was guaranteed fireproof and burglar-proof. (Courtesy of the Napa County Historical Society.)

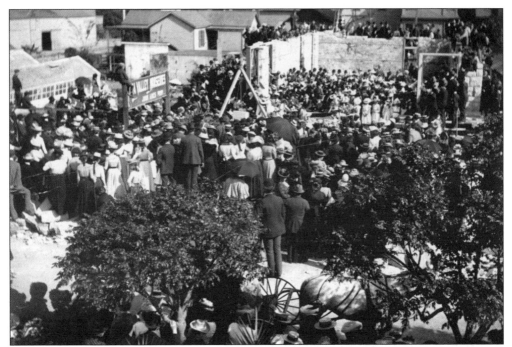

In 1901, the George Goodman family gave land, funds, and its name to the Goodman Library on First Street. Luther Turton was the architect. Shown here is the ceremonial laying of the cornerstone.

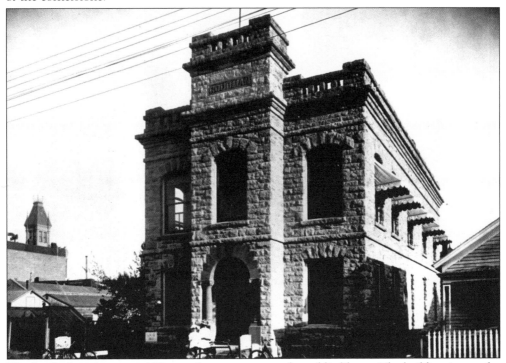

The finished product served Napans for many years as the public library. The building is now the home of the Napa County Historical Society.

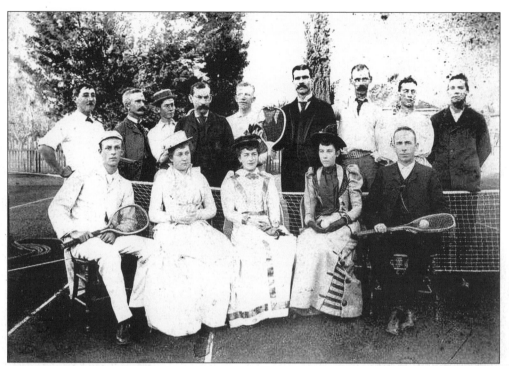

One of the Goodman daughters married a member of the Churchill family, which had parlayed its monetary success into a lifestyle that included a mansion with private tennis courts. Here, a group of social peers gathers at the family home in 1896. A match will undoubtedly follow. (Courtesy of Robert Northrop.)

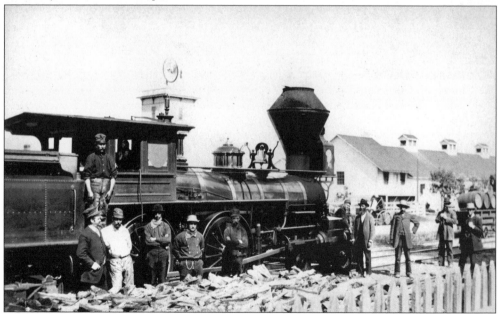

The Churchills purchased an Oakville winery, To-Kalon, from the Horace W. Crabb family. Horace's wife, Daisy, was a daughter of John C. Davis, one of George Yount's grandsons. Here, the train has stopped at the winery to load wood for fuel.

The Churchills, Goodmans, and Bickfords were Napa "banking families" and were regarded as local leaders. The first Napa Bickford, Leonard A., partnered with a man named Seely to found Seely & Bickford, located on Brown and First Streets. The Bickfords had a home on Franklin Street, shown here around 1890. They later moved to Calistoga Avenue. Posing at the Bickford home, from left to right, are Leonard Bickford, Addie J. Bickford, Elmer Bickford, and Emily Bickford. (Courtesy of Robert Northrop.)

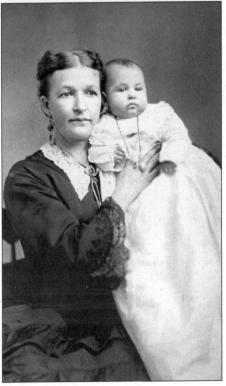

An adventurous life awaited little Adelaide Imogene Hayes, shown above in 1860. Addie Hayes became Addie Bickford. In the summer of 1874 she traveled from Virginia City to Laramie, Wyoming, and back again with the couples' son, Elmer, shown here. Soon after this picture was taken in 1876 the family moved to Napa, where they became important members of the community.

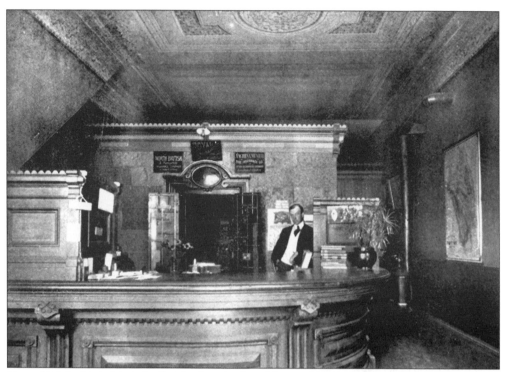

Elmer Bickford is behind the "wicket" at the First National Bank of Napa, successor to Seely & Bickford, which originally occupied the same site before moving across the street. He succeeded Harvey Goodman as president. (Courtesy of Robert Northrop.)

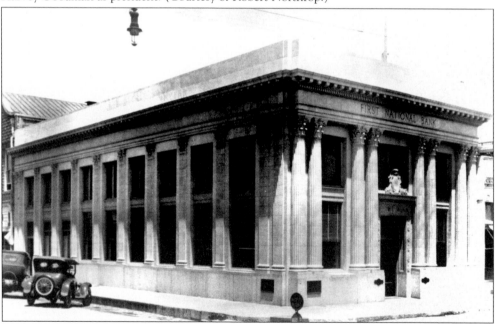

First National moved across the street to the northeast corner of Brown and First Streets and remained in business there until the Bank of America bought it in the 1920s. The building still stands and has been home to a number of other banks. In 2003, it became a restaurant.

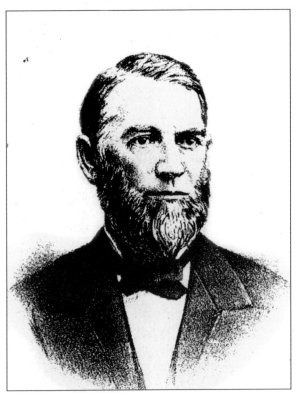

Chancellor Hartson was an especially noteworthy Napa pioneer. Lucky at gold mining, he parlayed his riches into power, serving as Napa district attorney, county judge, state assemblyman, state senator, and chairman of the state judiciary committee. He was also a charter member of the state Republican Party, founder of the Bank of Napa, the Napa County Insane Asylum, and the Napa Valley Railroad. (Sketch taken from Lyman Palmer's *History of Napa and Lake Counties California*, Slocum & Bowen Co., Publishers, San Francisco, 1881.)

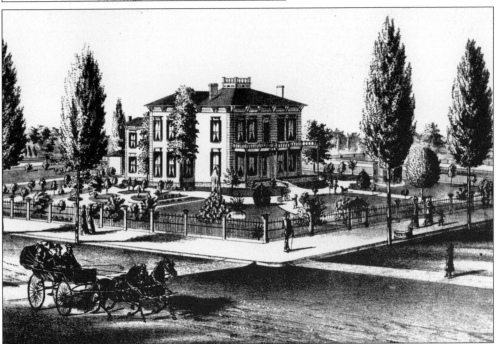

Chancellor Hartson's house, shown here, stood across from the courthouse on the corner of Coombs and Third Streets—directly in the center of town. The location was symbolic, because Hartson's control over the Napa Valley was pivotal.

Chancellor Hartson's son, Burnell, married a well-to-do young woman from St. Helena, Anne Gluyas, who was born in 1860. She died in 1886. (Courtesy of Anne Henry.)

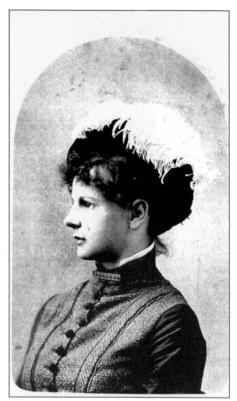

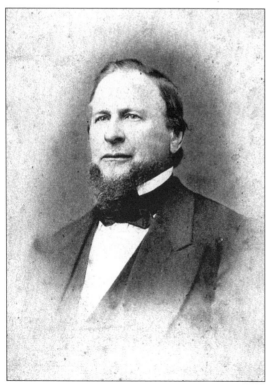

Anne Gluyas's father, George, was born in Cornwall, England, and was a ship captain. Upon retiring he bought property in St. Helena. (Courtesy of Anne Henry.)

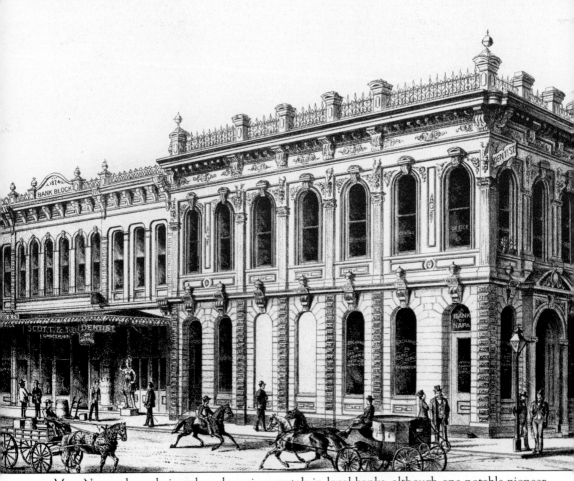

Most Napans kept their cash and precious metals in local banks, although one notable pioneer kept his in a coffin. The Bank of Napa, on the corner of Main and Second Streets, was the young city's second bank. When one crusty old miner became dissatisfied with the bank he'd been using, he piled his gold in a wheelbarrow and rolled it over to the competition. Note that the second story of this imposing building on the corner of Second and Main Streets is home to a dentist's office. This lithograph, like the others of places in historic Napa Valley, is from the Napa Valley Museum's collection of original prints by Smith & Elliot, Oakland, 1878.

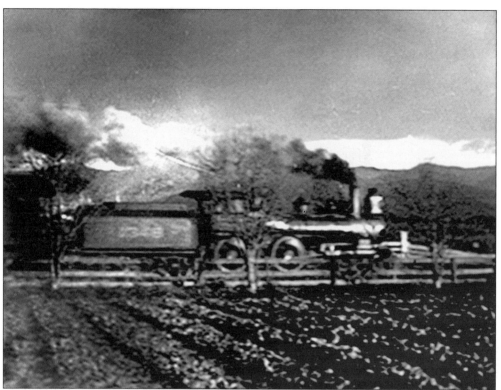

Under a dark sky, the original Napa Valley Railroad's locomotive burns wood to make steam, *c.* 1865. Chancellor Hartson was a key figure in bringing the railroad to the Napa Valley. Taxpayers were forced to pay for extending the line from Napa to Calistoga, which angered many as they had voted the extension down. Nevertheless it came, slicing through farmland and posing a serious threat to livestock. Resistance was futile.

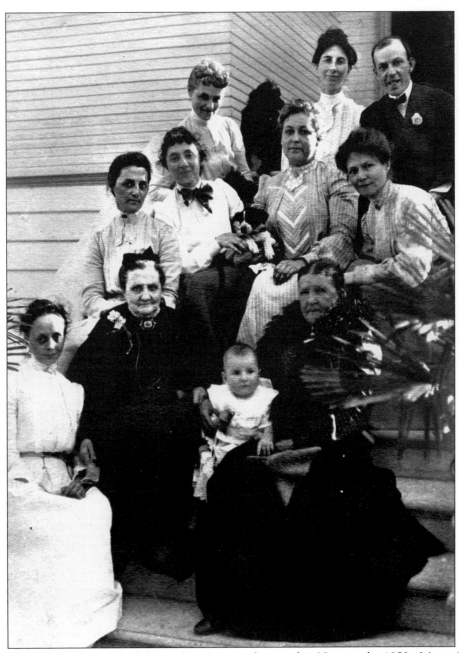

Anthony Y. Easterby, an Englishman from Liverpool, arrived in Napa in the 1850s. Most of his ventures proved profitable, beginning with a store on First Street. He also became president of the board of the Napa Valley Railroad. The railroading Easterbys and banking Bickfords were neighbors and close friends and gathered here for a group portrait on June 16, 1905. Shown, from left to right, are: (front row) Ethel Easterby, Mrs. A.Y. Easterby, Robert P. Bickford, and Mrs. Leonard Austin Bickford; (middle row) Florence Easterby, Frances Easterby, Emily Bickford (holding "Tick the Terrier"), and Lillian Cook Easterby; (back row) unidentified, "Mrs. Wiggs," Ada P. Bickford, and Elmer Bickford. Tick was so well known to Napans that when he died the newspaper ran an obituary. (Courtesy of Robert Northrop.)

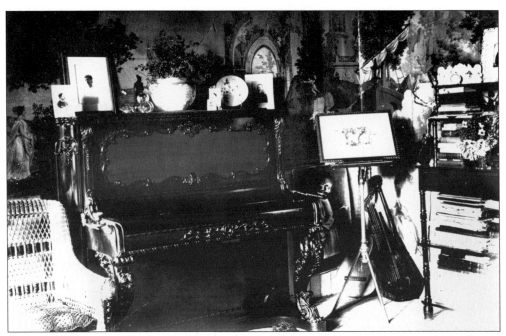

One room in the Easterby home was devoted to music. Lacking radio or television, families in the Victorian era often entertained themselves and each other with impromptu concerts. (Courtesy of Robert Northrop.)

Mothers and children often brought each other great delight. In the days before most women worked outside the home, child rearing was the mother's job. Amy Coombs Dunlap and her son, David, seem pleased with this arrangement. (Courtesy of Anne Henry.)

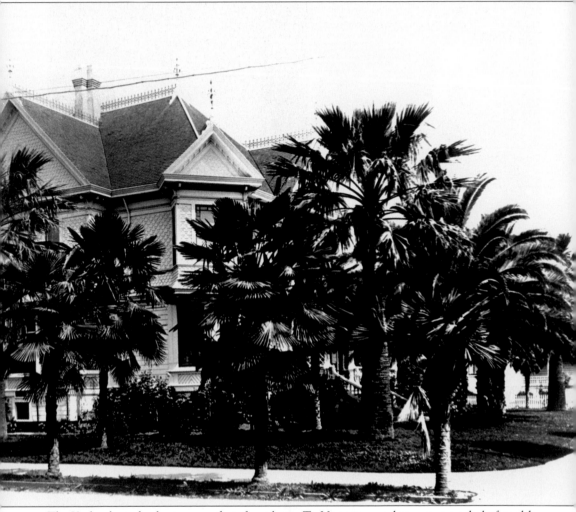

The Yorks planted palm trees on their front lawn. To Victorians, palms were a symbol of wealth, suggesting travel to exotic climes, a thrill available only to the well-heeled. Many of the old palm trees still grace the yards of Napa's old Victorian homes.

John T. York, photographed here in June 1928, was a Napa attorney. (Courtesy of John York.)

Another York descendent, Dan, became district attorney in the 1940s. Tough-minded and fair, he was instrumental in overturning the "good ol' boy" system that plagued the local courts, and he helped bring Napa into modern times.

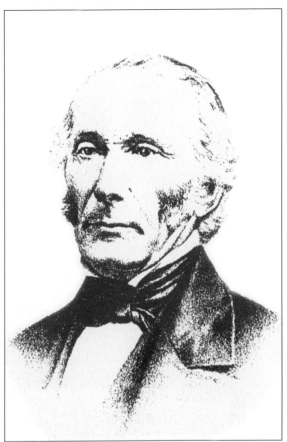

Like John S. Trubody, most Napa pioneers were honest and hardworking. Trubody left his native England in 1830 and by 1850 had made his way to Napa. Because early Napa boasted no schools or churches, Trubody at first ensconced his family in San Francisco. His first local job was harvesting the wild oats that grew all around the rowdy city of Napa. He eventually bought 184 acres just south of Yountville, which he turned over to his son, Josiah, and nephew, William, upon his retirement. (Sketch taken from Lyman Palmer, *History of Napa and Lake Counties California*, Slocum & Bowen Co., Publishers, San Francisco, 1881.)

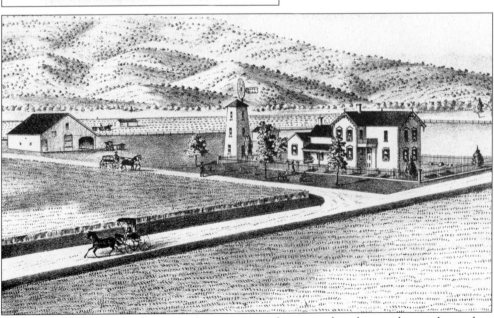

When John Trubody retired to a nice house in Napa, his son and nephew took over the work at the ranch. They planted 27 acres of blackberries that won them statewide recognition.

36

In the 1870s the Southern Pacific Railroad planted 1,000 eucalyptus trees between train stations, with the idea that they could be harvested for use as tracks and fuel for the steam engines. Unfortunately, they proved ill-suited for either. Eucalyptus trees were also thought to be effective in fighting malaria, and although this was another myth, the incidence of the dreaded disease did decline in California after they were planted. The massive "Trubody Eucalyptus" is a familiar sight on Highway 29.

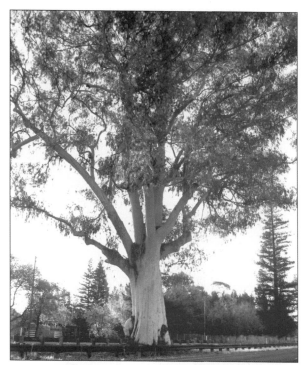

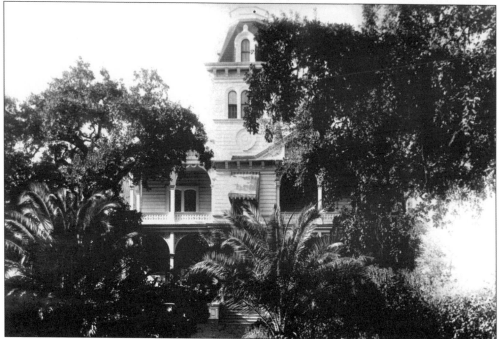

A shipmaster from Massachusetts named Joseph Osborne retired to an oak-filled tract of land near the Trubody place in 1858, built a home, put in an orchard, and was murdered there by a ranch hand from Rhode Island in 1862. A San Franciscan, R.B. Woodward, bought the property after Osborne's death and built a mansion, Oak Knoll, in 1872. The Melone family eventually acquired Oak Knoll. Note the palm trees, symbols of affluence.

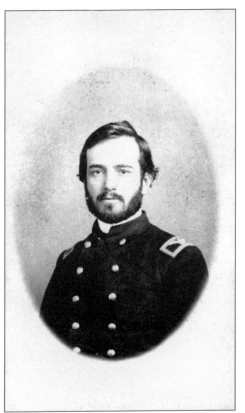

John Franklin Miller, a lawyer, first came to the Napa area in 1853, preceding George Goodman as county treasurer. Prior to his arrival, Miller had led a group of volunteers in a battle against the Modoc Indians in the lava beds near Tule Lake, and his success won him some acclaim. When the Civil War broke out he returned to his native Indiana, where he served heroically as a Union general. He came back to California after the war ended and became president of the San Francisco-based Alaska Commercial Company, which trapped and sold furs worldwide.

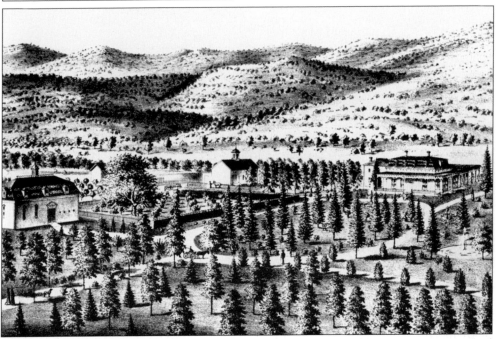

Miller built a country home in Napa that he named Lavergne after his most prominent Civil War victory. Today it is the Silverado Country Club.

Long before Miller's place became a resort, Napa had a world-class tourist attraction in the same general area. John P. Jackson, a Kentucky attorney who became editor of a San Francisco newspaper, claimed title to view acreage some eight miles from town. After fighting off other contenders for the land in a series of hot legal battles, he was able to host a lavish grand opening for Napa Soda Springs in 1881. Neighbors, both Miller and Jackson served terms as customs collector of the Port of San Francisco, a position also held at one time by Chancellor Hartson and Eugene L. Sullivan. (Sketch taken from Lyman Palmer's *History of Napa and Lake Counties California*, Slocum & Bowen Co., Publishers, San Francisco, 1881.)

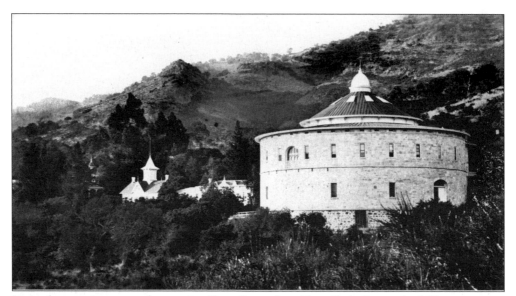

Hewn from native stone, the massive Great Rotunda at Napa Soda Springs had 50 guest rooms. The view from the rotunda was inspiring, although the building was originally intended to be a horse barn. (Photo by Napa photographer Mark Strong.)

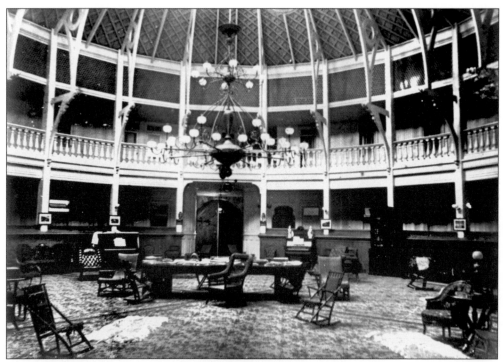

The Great Rotunda was posh enough to please upscale guests like former U.S. president Benjamin Harrison and the royals Maximilian and Carlotta of Mexico. The latter also spent time at another Napa Valley Resort, Stag's Leap.

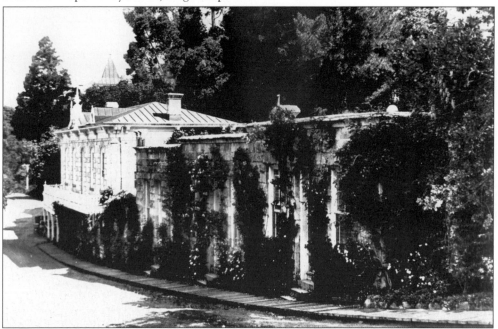

Many springs, each dominated by a different mineral, bubbled forth at John P. Jackson's resort. He shrewdly placed most of the structures near them. There was also an independently operated Napa Soda Springs bottling plant, where carbonation was added to the mineral water.

Alma Spreckels, of the famous sugar-refining family, built a 57-room mansion on the site of an old horse farm south and slightly west of Napa City. She filled it with *objets d'art*, many guests, lively conversation, and, during Prohibition, a plentiful supply of bootlegged alcohol. Arsonists burned down the elaborate "Alma Villa" in 1928.

Like her predecessor, Alma raised racehorses at the Spreckels's Napa ranch. The stables, shown here, survived the fire that destroyed the mansion in 1928. In recent times they have been used as apartments.

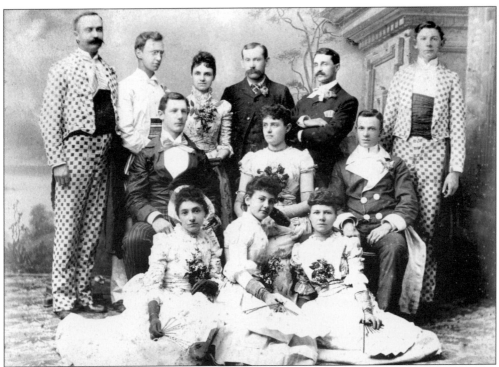

Staged performances with local casts provided entertainment for the citizens of Napa City. The gentlemen's costumes here suggest a comedy or a minstrel show. (Courtesy of Robert Northrop.)

Unstaged performances were also popular.

Three

THE BEAUTIFUL BEAST

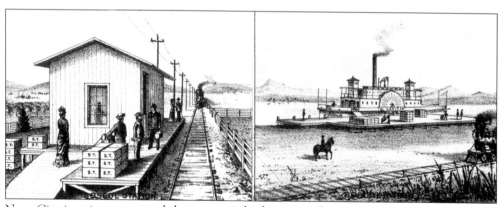

Napa City is a river town, and the waterway leading to its doorstep has been both friend and foe—a gentle method of transport that stimulated commerce in the city's early days, and a raging monster that wreaked havoc during winter storms. A tiny town called Suscol once clung to the river's edge near today's Southern Crossing, getting its start around 1850 when brothers Simpson and William Thompson bought 300 acres of swampy cattle country from Mariano Vallejo and John Frisbie. They drained the area and planted grain and fruit trees. Thompson Gardens became an important supplier of fresh produce, especially fruit, for the Gold Rush miners. Both the train and the ferry stopped here, as evidenced by this photo. The "S.T." on the boxes probably stands for Simpson Thompson.

Simpson Thompson's residence was located near the wharf. Thompson's Gardens peaches retailed for $1.25 each at the height of the Gold Rush, and their plums brought in almost that much. In 1856, their farm and orchard yielded about $40,000.

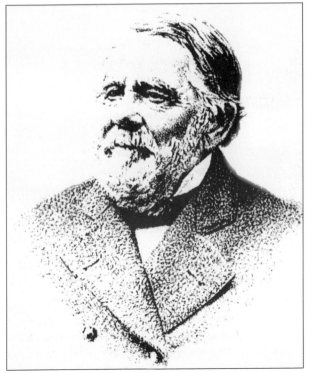

When brother William left to raise cattle in Texas, Simpson Thompson took full charge of Thompson's Gardens. Other farmers used Thompsons's fruit pits to plant orchards of their own. Ultimately Thompson's Gardens could not compete in the market, and the company and the little town of Soscol vanished.

The Napa River's estuary on San Pablo Bay is a vast wetland and such a vital habitat for so many species of birds that the American Bird Conservancy has named the Napa Marshes a "Globally Important Bird Area." The Cargill Salt Company, and prior to 1978 the Leslie Salt Company, utilized much of it as a saltworks for many years, creating evaporating ponds to separate out the salt crystals suspended in the water. In 1994, Cargill offered to sell its Carneros district salt ponds—some 9,000 acres in all—to the California Department of Fish and Game. As soon as the deal was sealed, the fish and game department launched a project to reduce the salinity of this extremely important area so that the ecosystem's health could be restored. (Map by U.S. Geological Survey.)

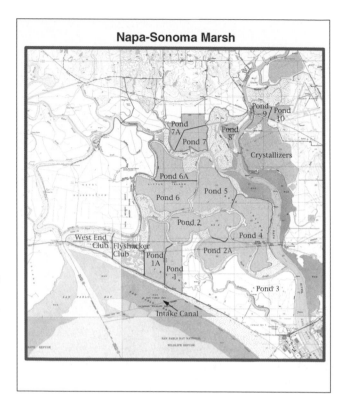

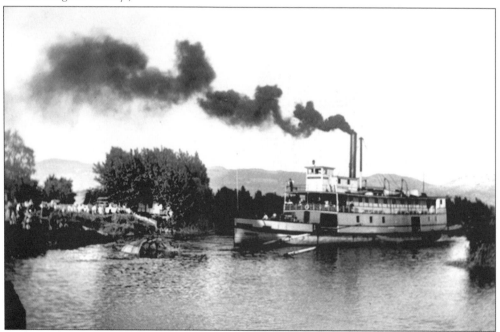

In the 19th century the river was an easy, but far from foolproof, way to transport goods and people. Here, the steam-powered ferry *Zinfandel* has encountered a sloop—and the sloop is sinking. (Courtesy of John York.)

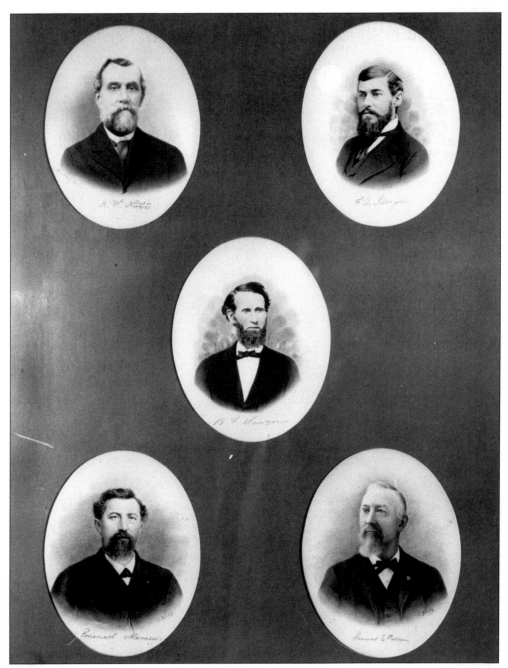

French Albert Sawyer, a New Hampshire man exploring new business opportunities in the golden West, *c.* 1870, noticed that Napa slaughterers were discarding sheepskins with the wool still on them. He and his father, a currier, started a wool-pullery with the discarded pelts and soon expanded to tanning the hides as well. A.W. Norton and S.E. Holden lent capital to the enterprise and the plant manager, Emanuel Manasse, invented ways to improve the product. Shown, from left to right, are (bottom row) Emanuel Manasse and Sam Holden; (center) B.F. Sawyer; (top row) A.W. Norton and F.A. Sawyer. (Courtesy of Sawyer of Napa.)

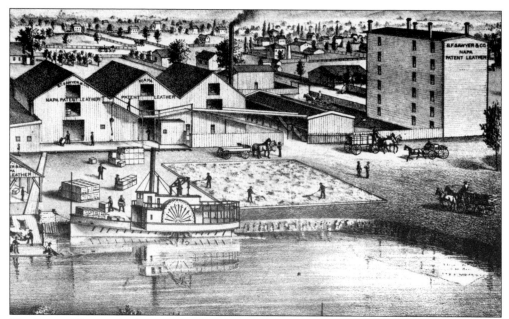

The Sawyer Tannery had its own landing and used the river for shipping its fine leather products. Starting with only one employee, it grew into a major Napa employer with customers all over the world. Unfortunately, Sawyer's found the river to be a practical receptacle for waste and pumped its highly toxic effluent into it for decades.

The Sawyer Tannery remained in business until the late 1990s. By then, man-made fabrics, often assembled in other countries with cheaper labor, made wool linings a specialty item too expensive to mass-produce, thus ending the 120-year-old Napa industry.

Sawyer's wasn't the only Napa company in the leather and hide business. The McBain Tannery, shown here, also poured effluent into the river.

The Evans Shoe Company was located on the east side of the river, just south of town, convenient to both river and train. It made use of Manasse's "napa leather" (a buzzword in its day) to produce "Nap-a-tan" shoes.

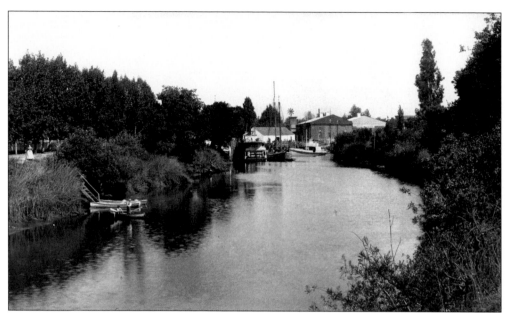

Approaching Napa, the photographer finds a boy with what may be a fish on his line. Despite the toxic waste in the river, people routinely ate the fish they caught in it. The windmill above the river's vanishing point belonged to the Bachelder Manufacturing Company.

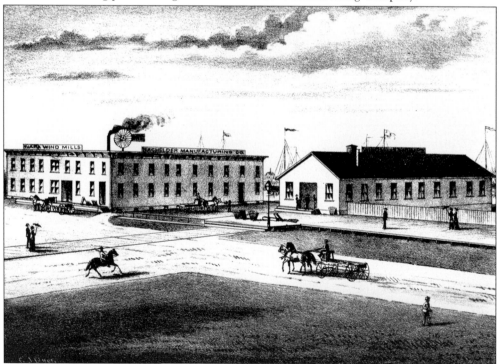

Bachelder Manufacturing was conveniently located near the river and the train depot. The company built windmills that powered special pumps to lift water from streams and distribute it through irrigation pipes to farmers' crops. Bachelder products routinely won prizes at the California State Fair.

In this early morning photograph, a boat is moored up-river from the Uncle Sam Winery. The winery, established around 1873, was the largest in Napa, but ultimately did not enjoy the same success as many of the wineries located in Up Valley. Perhaps the relatively humid river location

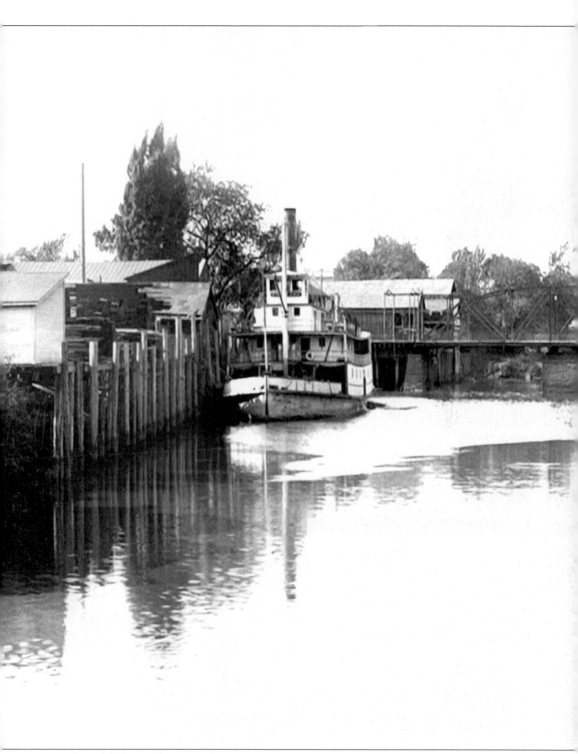

was unfavorable for producing and storing wine. It may have been issues of quality that induced its owners to build a vinegar factory and a brandy distillery on the property.

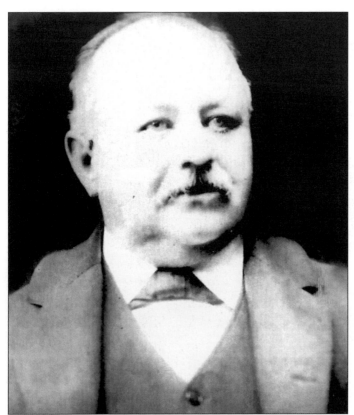

Prussian-born Albert E. Hatt captained a boat that plied the waters of the Sacramento River before he became a Napa City merchant. Hatt owned the schooner *Amelia* and was part-owner of the ferries *Napa City* and *St. Helena*. He built the Hatt Building as a warehouse and eventually bought the adjacent lumber business as well. (Courtesy of the Napa River Inn.)

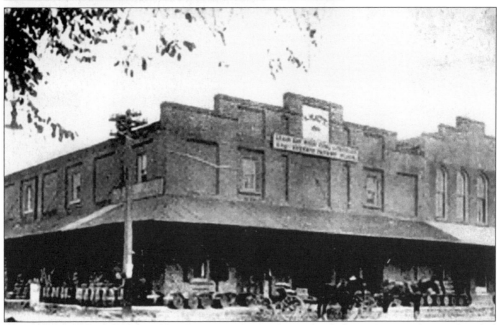

The Hatt Building had a roller-skating rink on the second floor. It served as a bonded warehouse for wine storage, but Hatt also stored coal and grain on the property. (Courtesy of the Napa River Inn.)

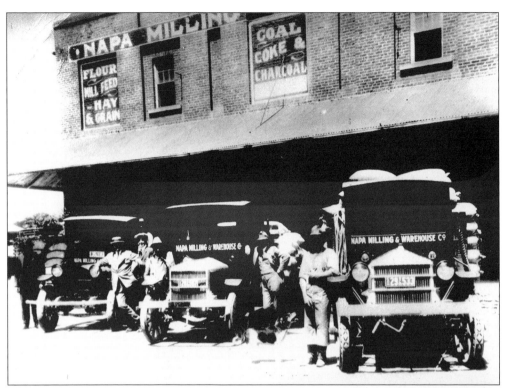

The Keig family bought the Hatt Building in 1912 and used it to house their Napa Milling company. The Keigs were related to several other Napa families who were especially important just after the turn of the 20th century, among them the Corletts and the Yorks. (Courtesy of the Napa River Inn.)

World War I veteran Robert Keig purchased Napa Milling from his siblings. When rivers gave way to highways for transportation, the building's location became less of an asset. Eventually the docks fell into disrepair. (Courtesy of the Napa River Inn.)

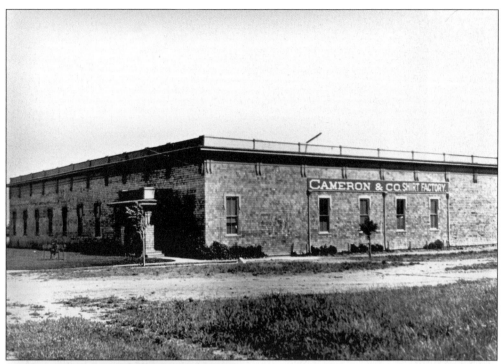

The Cameron Shirt factory also fronted on the Napa River.

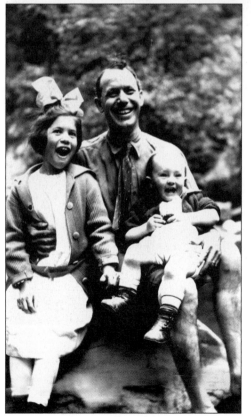

"Grandpa" Gans, a co-founder and executive at Cameron Shirt, enjoys his children in this lively 1919 family photo. Like many other Napa businesses, Cameron Shirt declined after the Great Depression, but may have been operating as late as the 1950s.

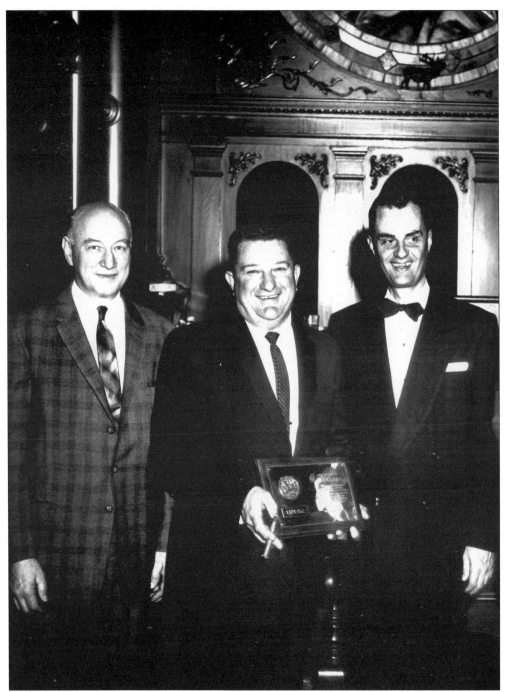

To stimulate the economy, Napa leaders enticed Nat Rothman (left), an Oakland garment manufacturer, to set up business in the old Cameron Shirt building. Arriving in America destitute, he began work as a janitor and went on to found a multi-million dollar company named Rough Rider. A leader in the community, Rothman was an inspiration to many. He is seen here with liquor distributor Ray Cavagnaro (center) and attorney Tom Kongsgaard, who went on to become a Napa Superior Court judge. (Courtesy of the Cavagnaro family.)

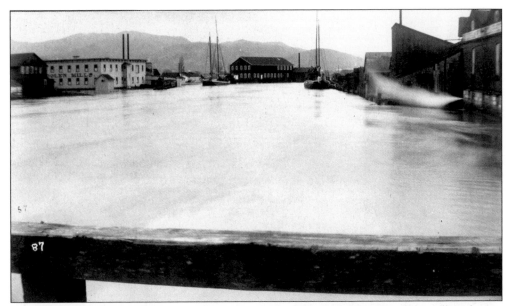

The pumps at Uncle Sam's Winery are running full speed as workers try to rid the cellar of water in 1890. Napa Woolen Mills (the white building at far left) and McBain's Tannery (center) are also flooding. Water is pouring over the banks and inundating the residential district to the right of the picture. (Courtesy of the Napa County Historical Society.)

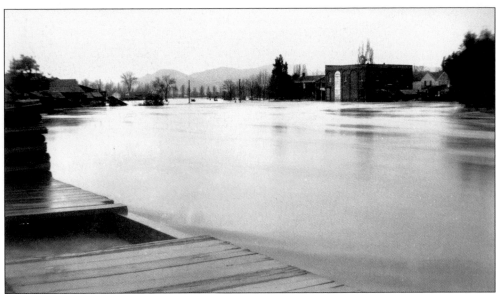

Tame and picturesque though it was in good weather, the Napa River could also become an ugly beast. It has flooded many times since Napa was founded in 1848. Raging waters carried away bridges and sometimes homes, creating debris piles that would lodge and act as dams, causing the banks upstream to overflow. A photographer was present in 1890 to capture this winter's flood on film. (Courtesy of the Napa County Historical Society.)

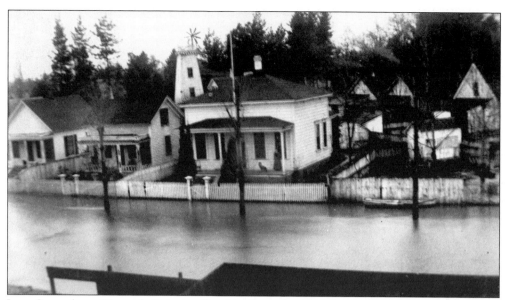

Levy Street (now Riverside Drive) suffered badly in the 1890 flood. This location is part of the residential area just south and west of Uncle Sam's and the Hatt complex. (Courtesy of the Napa County Historical Society.)

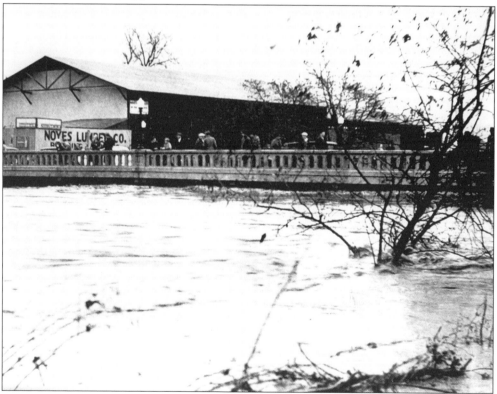

In 1940, the floodwaters rose again, just as high as they did in 1890. Spectators crowded the bridge, apparently confident of the structure's ability to support them. (Courtesy of the Napa County Historical Society.)

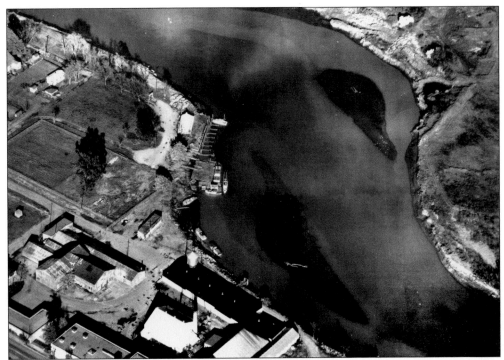

A natural bend in the river at the Napa Valley Yacht Club's pier, shown in this 1955 aerial view, caused flooding and erosion of the banks during heavy weather. (Courtesy of the Napa Valley Yacht Club.)

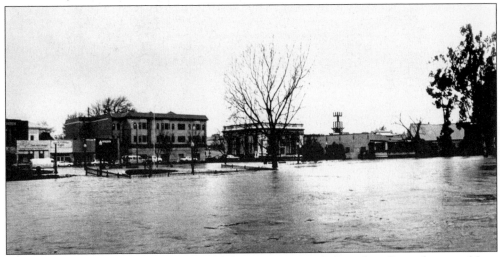

The flood of 1986 killed three people and left many temporarily homeless. Since that time Napa has undertaken an aggressive flood-control project designed to allow the river to exceed its banks where it will do no damage while protecting vulnerable areas from dangerous high waters. Forbidden is the practice of using the Napa River as a waste receptacle, and clarity and health are slowly returning to this important riparian corridor. A hefty $170 million has been slated for the comprehensive Flood Protection Project, which includes the re-establishment of natural floodplains and the creation of new levees, culverts, bridges, and other infrastructure upgrades. (Courtesy of the Napa County Historical Society.)

Four

NAPA CITY

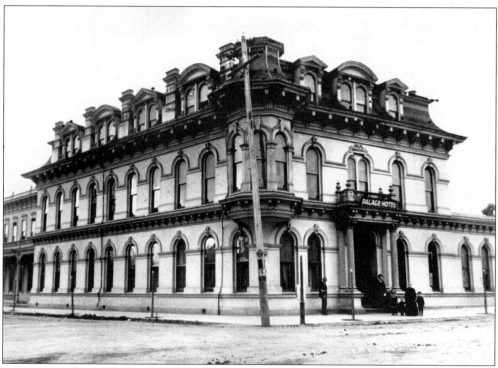

The Palace Hotel once stood proudly on the southwest corner of Soscol Avenue and Third Street, just southeast of the Third Street Bridge, with an attached livery stable on the south side. Like its elegant namesake in San Francisco, the Palace was the best hotel Napa City had to offer for many years, but time took its toll on the ornate Second Empire–style building, and it was eventually demolished. Many of Napa City's distinguishing landmarks succumbed to the ravages of time. Even the city's name changed when, sometime around the turn of the 20th century, Napa City became simply Napa.

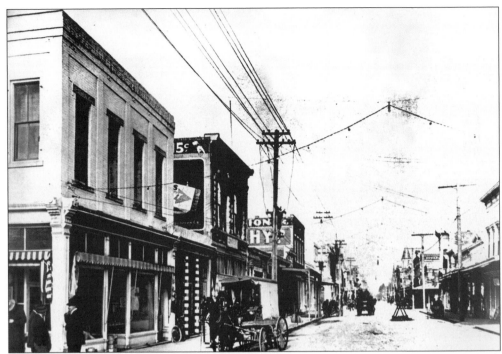

This fading, turn-of-the-20th century picture captures the view north at Main Street and Third. Apparently shot in the early afternoon, the photo suggests traffic was light in Napa City that day. In fact, Napa City did not grow as rapidly as the other major Bay Area cities, a matter of great concern to local leaders at the time.

The gas-lit Corral Bar, part of the Conner Hotel, once greeted visitors as they crossed over the Third Street Bridge into Napa. The hotel was built in 1912, after Napa had already dropped the "City" from its name. The Conner Hotel (seen above after a later remodel) replaced a livery stable and a bicycle shop. At the time, it was considered an improvement, although later the Conner gained a questionable reputation. Several members of its staff were arrested during Prohibition (1920–1932) for alcohol violations, and Baby Face Nelson, one of John Dillinger's machine gun–toting henchmen, cooled his heels here under the protective watch of Joe "Fatso" Negri, a San Francisco hoodlum with links to the Napa Valley. (Courtesy of the Napa Economic Redevelopment Office.)

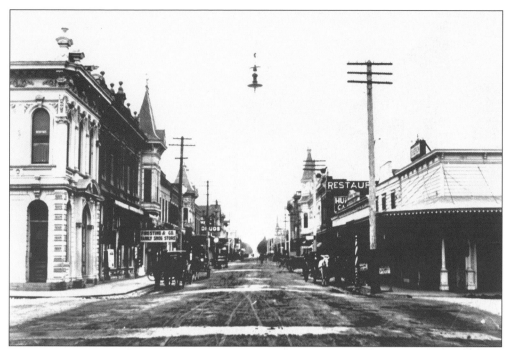

This view, again looking north, shows the intersection of Main and Second Streets. The Bank of Napa is on the left (northwest) corner, the Oberon Bar on the right (northeast). In 1901, Dr. C.H. Farman, a hatchet-wielding Prohibitionist, was arrested for attempting to "Carrie-Nationize" the Oberon, having already wreaked havoc at the bar at the Revere House hotel.

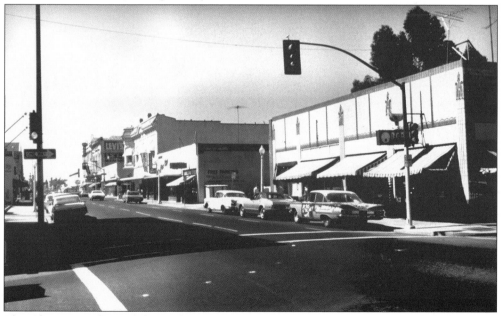

The Oberon Bar (far right) somehow survived Prohibition and was back in operation in the 1960s. The free parking lot was once Schwarz Hardware, a popular Napa store with roots in the 19th century. It burned down in the mid-20th century. (Courtesy of the Napa Economic Redevelopment Office.)

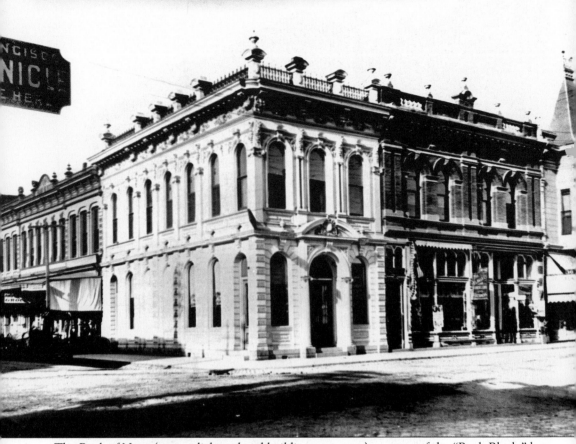

The Bank of Napa (center, light-colored building on corner) was part of the "Bank Block," but other stores, like a grocery, also operated there. Second Street is to the left. David Haas's shop is next door to the right. Haas and his brothers, Martin and Solomon, were very successful stationers and tobacconists, and David became a director of the bank. At various times, the Haas brothers had branch stores in Calistoga, St. Helena, and Lake County, and were owners of a quicksilver mine.

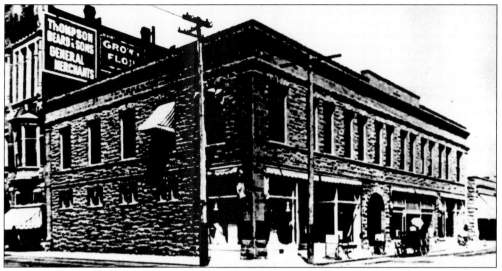

The Behlow Building on Second and Brown Streets, the smaller of the two structures shown here, was the work of Napa architect Luther Turton and was built with locally quarried stone. Numerous professional offices operated out of the second story, while the ground floor belonged to Thompson, Beard & Sons, a large mercantile store that advertised itself on the building next door. When a fire gutted the Behlow during the Depression, Thompson & Brown closed for good.

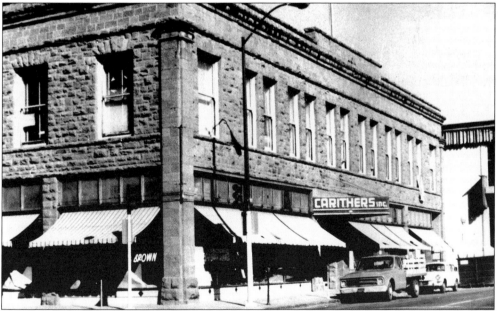

The Carithers Department Store of Santa Rosa bought the Behlow Building and operated it for 40 years until it was flattened in 1977 to make way for a parking lot. Removing the Behlow Building and installing a parking lot was a difficult decision. Listed on the National Register of Historic Places, the Behlow Building had historic and sentimental value, but parking was (and is) a serious challenge in old town Napa, and community leaders believed that if Napa was to develop, infrastructure changes needed to be made. (Courtesy of the Napa Economic Redevelopment Office.)

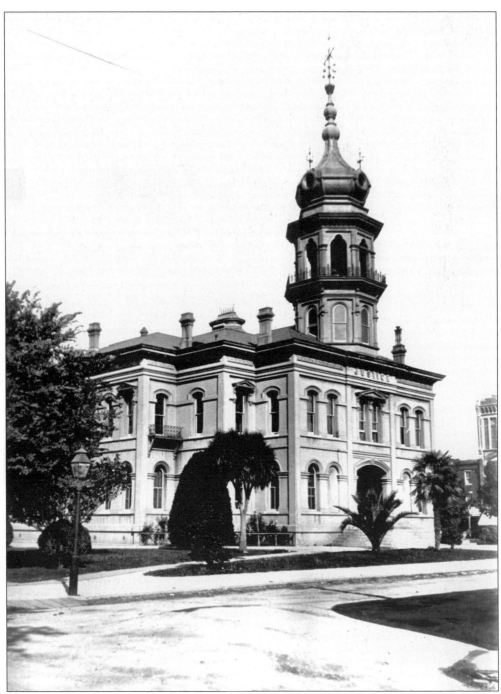

Photographer Mark Strong's images of Napa, taken around the turn of the 20th century, are an important resource for local history. This classic image of the Napa County Courthouse shows the massive and very ornate cupola, on the top of which was a bell. City officials sounded the bell during times of great urgency—it rang, for example, when Lincoln was assassinated. The cupola and bell collapsed during the 1906 earthquake and fell into the offices of Superior Court Judge Henry Gesford, who was fortunately still at home at 5:12 a.m., when the quake hit.

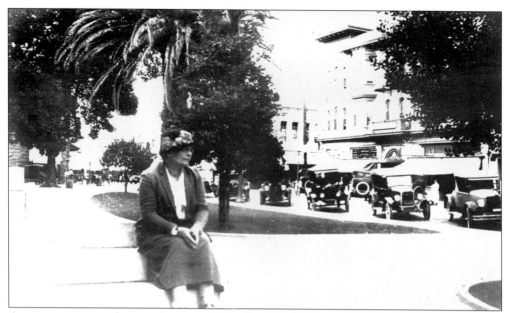

A woman rests on the courthouse steps in this Prohibition-era photo. The courthouse is on Second and Brown. The Alexandria Hotel is to the right, across Brown Street. (Courtesy of the Napa County Historical Society.)

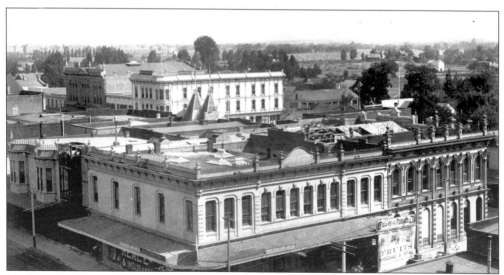

Mark Strong set up his camera in the courthouse cupola to take this picture. The "Bank Block" on Second Street is in the foreground, with the Napa Hotel (tall, light-colored building) and the Opera House (darker-colored tall building) beyond them on Main near First.

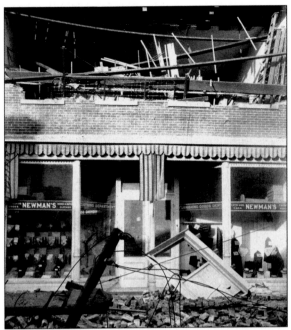

The second story of this Napa City building received heavy damage in the 1906 quake, but Newman's clothing store on the first floor seemed untouched. The newspapers reported that not a single chimney in town was left standing, which may have been an exaggeration. Napans mobilized immediately to help quake and fire victims in San Francisco. (Courtesy of Robert Northrop.)

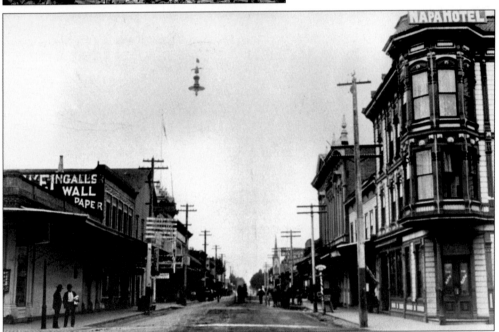

The Napa Hotel appears to be listing toward the street from its location on the northeast corner of Main and First. It survived the 1906 earthquake, but the south wall of the Opera House next door fell onto the one-story Napa Hotel annex. The brick landed in the room of a hotel guest who was understandably rattled, but unscathed. The big wooden hotel building survived several fires, but was finally torn down before the Great Depression. This image shows the intersection of Main and First, facing north. The spire on the east side of the street belongs to St. John's Catholic Church. Levinson's clothing store is opposite the Napa Hotel on the west side of the street.

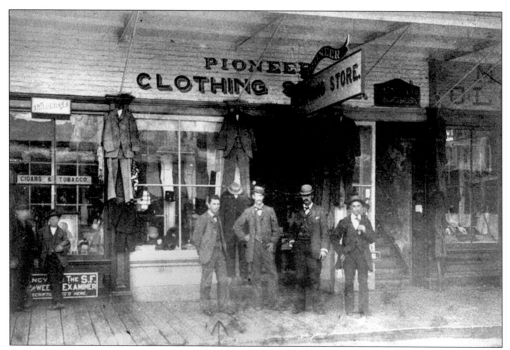

Over the years, members of the Levinson family owned or worked in stores in many Napa locations, most of them, like the Pioneer Clothing Store, on Main Street. Charlie Levinson was in the retail garment business; brother Joe was a pharmacist. The wooden sidewalk in this very old photo (1870s) is well worn. (Courtesy of Claire Erks.)

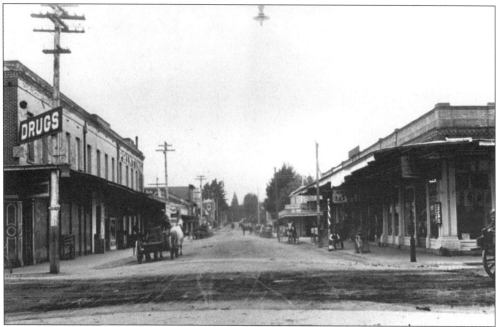

This view looking west at the corner of Main and First Streets shows that the Levinsons' enterprises dominated the intersection. Charlie Levinson's clothing store moved to a location on the north side, and Joe's pharmacy was on the south side of the street.

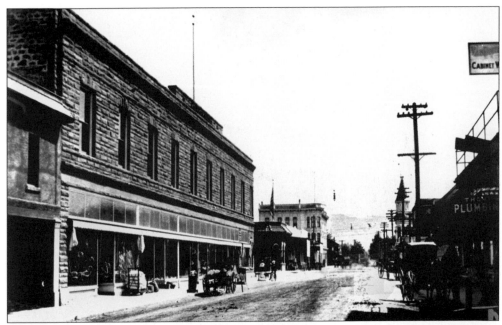

This image was taken two blocks to the west and facing the opposite direction from the previous photo, from Coombs eastward along First Street. The turret of the original Winship Building stands watch over the Main and First Street intersection at right. Across from it on First Street is the Napa Hotel on the left. The large building in the left foreground is the Migliavacca Building, which had just been completed when the picture was taken in 1905.

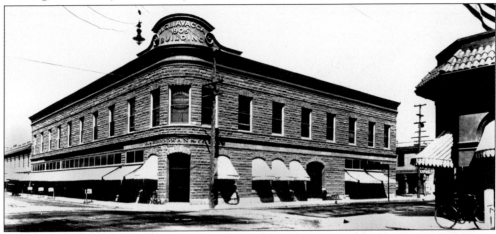

G. Migliavacca came to California from Italy in 1858. By 1866, he had a small grocery store on Main Street and made his own wine in the back, which he stored in a building called Crowey's Store, across the First Street Bridge in East Napa. Migliavacca learned winemaking from his father, and thus was one of the few wine-industry pioneers with actual training. The quality of his wine was reported to be very good. By the turn of the century he was able to build the big structure seen here. After the 1906 earthquake damaged his building on the northwest corner of Brown and First, he not only expanded it but also bought the Uncle Sam Winery. The J.H. Goodman Company moved from its prior location on Main Street and occupied part of the ground floor, as shown here. A corner of the First National Bank is visible on the right, beneath the flag.

This is the northeast corner of Brown and First, photographed in the 1880s or earlier. Most of the people on the wooden sidewalk are employees of the wholesale liquor company located here. (Courtesy of Robert Northrop.)

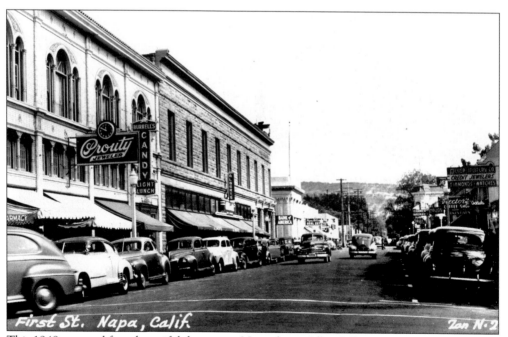

This 1948 postcard from beautiful downtown Napa shows Albert's Department Store occupying the Migliavacca Building, with the Bank of America located where J.H. Goodman had been. Jewelry stores, drug stores, and coffee shops competed with each other for customers.

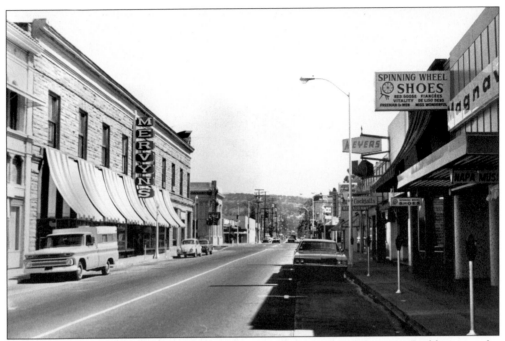

A successor to Albert's, Mervyn's Department Store in Napa's Migliavacca Building was the second in what has become a major retail chain. The first Mervyn's was built in San Lorenzo. Mervyn's remained in Napa, but the Migliavacca block succumbed to redevelopment. This view is of First Street facing east. (Courtesy of the Napa Economic Redevelopment Office.)

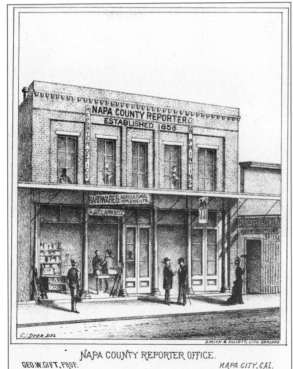

Napans got their information from newspapers like the *Napa County Reporter*, which published from the top story of this building. The *Reporter* was the town's first newspaper, making its debut on July 4, 1856. Its publisher was A.J. Cox, a scrappy veteran of the Mexican-American War who had gone gold mining with Salvador Vallejo and a group of other Napa men. The paper began as four columns that were printed on a Mexican press that somehow made its way to San Francisco, and at first it didn't appear with any regularity. Throughout the Civil War the *Reporter* tended to support the South, as did the *Pacific Echo*, another Napa paper, which folded the day Lincoln was assassinated. The *Napa Herald* and its successor, the *Napa Times*, were also strongly pro-South; neither lasted very long.

The *Napa Daily Register* and its weekend counterpart, the *Napa Weekly Register*, competed with the *Reporter* and the Southern-sympathizing newspapers for many years. The *Napa Daily Register* supported the Republican Party and was strongly pro-Union during the Civil War. Many people also read San Francisco newspapers. Before the age of radio and television, newspapers were the primary source of information.

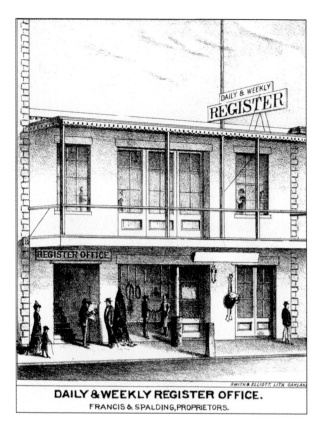

DAILY & WEEKLY REGISTER OFFICE.
FRANCIS & SPALDING, PROPRIETORS.

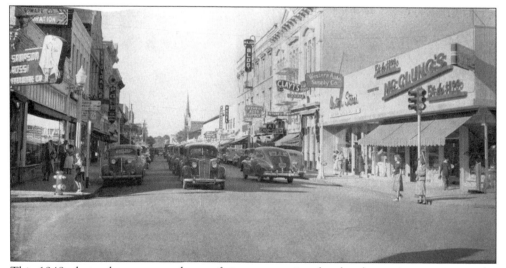

This 1948 photo shows a cacophony of signs competing for the shopper's attention at the northern intersection of Main and First Streets. McClung's, on the far right, located on the site of the old Napa Hotel, later became Brewster's. (Courtesy of the Napa Economic Redevelopment Office.)

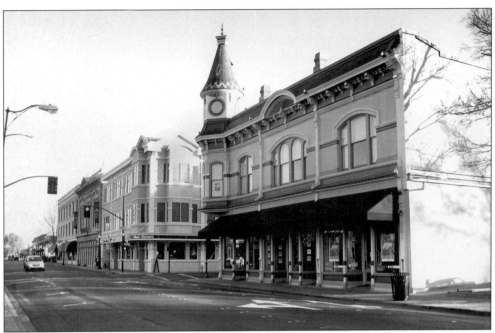

The Winship Building is arguably the quintessence of Victorian Napa. Situated on the southeast corner of Main and First Streets, its fanciful tower inspires a new appreciation for the work of its original architect, Luther Turton. Much of Turton's work was damaged in the 1906 earthquake.

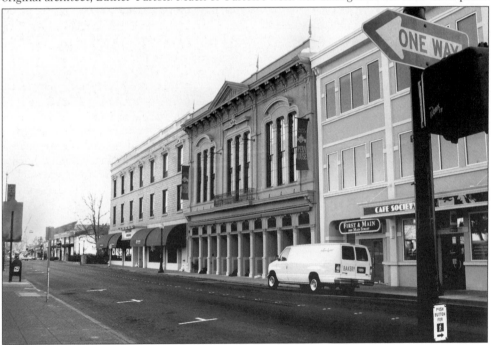

Formerly Crowey's Napa Opera House, the Italianate building in the center of this block took years and $14 million to restore. Like the Winship Building, it represents Napa's yearning to remember its past as a thriving post–Gold Rush community. It opened in 2003 amidst much fanfare, and succeeding months have seen a full schedule of first-rate, live entertainment.

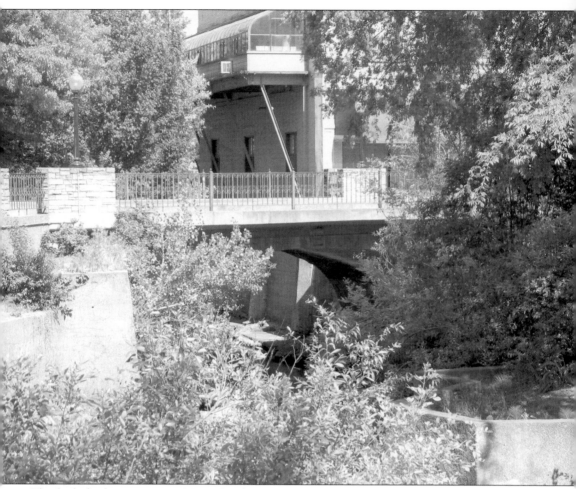

The little bridge going over Napa Creek on Main Street is the oldest still in regular use in California. It was built around 1860. The earliest Napa bridges were wooden, but they tended to collapse during winter storms. Fallen bridges dammed the water and flooded the town on a regular basis, hence the need for stone. Old stone bridges abound in Napa County, having survived earthquakes as well as floods. The Putah Creek Bridge, now under Lake Berryessa, was the largest stone span west of the Rockies. Napa stonemason R.H. Pithie built it and many of the other stone bridges of Napa County.

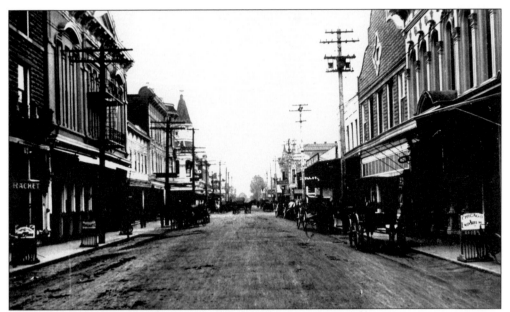

Seen from Pearl Street (one block north of First), Main Street was oppressively crowded in 1900. The Winship Building is the towered structure left of center. The old opera house is also on the left, behind the telephone pole nearest the camera. The opera house offered live vaudeville shows presented by performers who usually arrived in Napa by train. The Chicago Emporium, a department store, is to the far right.

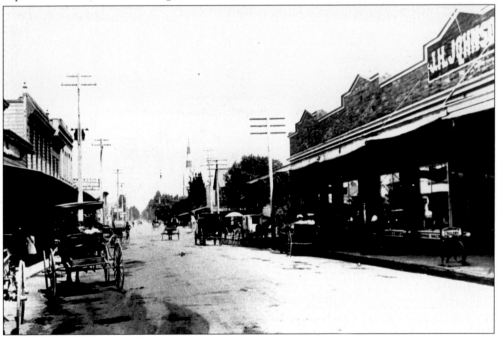

Named for an early Napa mayor, the Kyser Building, located between First and Pearl Streets, has housed many businesses since it was constructed in the 1880s. Across the street, the Carbone family sold groceries, liquors, and Napa Valley wines. Antone Carbone was the first Italian to serve on the Napa County Grand Jury.

Five

FOR THE PEOPLE

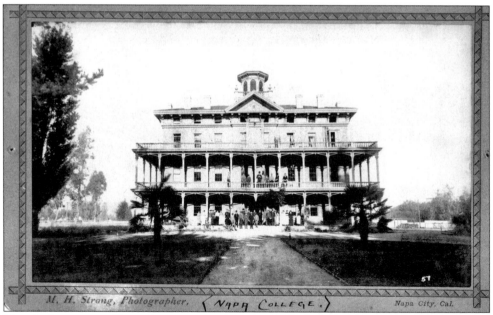

M. H. Strong, Photographer, ⟨ NAPA COLLEGE. ⟩ Napa City, Cal.

Napa had so many public and private schools in the 1880s that a newspaper editor once referred to the city as "the Oxford of the Pacific," a rather egregious overstatement, but well intended. Sawyer Tannery executive Abraham Norton helped to found the first Napa College, shown here, before 1870. The college stood on a slight rise on five acres near what today is Jefferson Street between Seminary Street and Calistoga Avenue. It relocated to San Jose to become part of the new state university system.

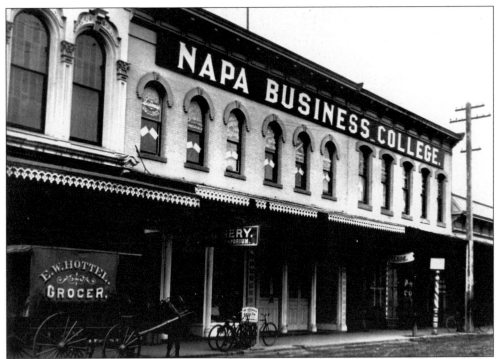

Harry Gunn, one of the instructors at the first Napa College, remained in Napa and founded Napa Business College, where many local leaders received their higher education. Adults could go to the large brick structure next to the Chicago Emporium on Main near Pearl and pay $30 for a complete six-month business course or $15 for training in penmanship.

Young women of means could also receive higher education. This was the women's dormitory for the Napa Collegiate Institute. The main part of this building now serves as the Polk Street Apartments at 1556 Polk Street in Napa.

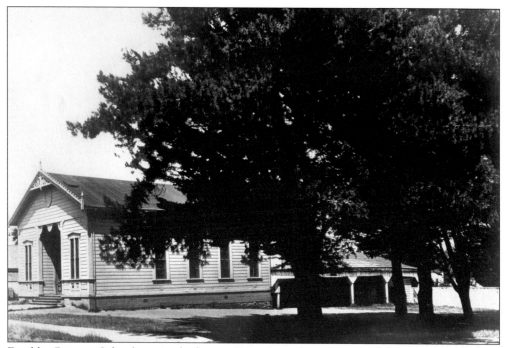

Franklin Primary School was in the heart of Napa's residential area and thus drew from a large population. The structure in the back may have been a stable for the teachers' transportation. The school was reconfigured in the late 20th century into the Napa Women's Club building at 218 Franklin Street.

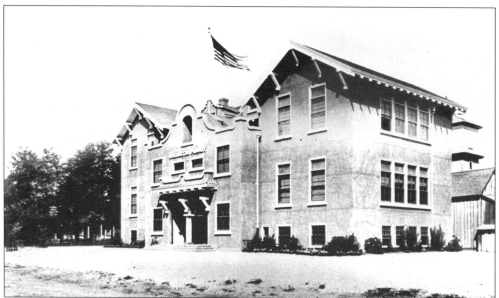

Washington Primary School was another elementary school in Napa. Before the automobile, children walked (or in some cases rode their horses) to attend class. John Imrie, superintendent of schools in 1900, had a budget of $17,000 to spread among eight districts in Napa. Napa architect Luther Turton designed this and many other local buildings. Lovingly restored, it is now the Blue Oak School, a recipient of Napa County Landmark's Award of Merit in 2003.

John L. Shearer (center) was an innovative and inspiring local educator. To solve the problem of early dropouts, he instituted the practice of sixth-grade graduation, giving youngsters a more immediate goal. This is the Central School graduating class of 1907. Another Napa educator, Miss Kate Ames, made her mark by becoming one of California's first female school superintendents. She was on the Republicans' slate of potential nominees for state superintendent of schools in 1906, but didn't make the ticket. "I found that the machine was too much for me," she said afterward. (Courtesy of Robert Northrop.)

Young Helen Buckley stands with her cat on the steps of her Calistoga Avenue home. She had attended Washington Primary. (Courtesy of Lorrain Kongsgaard.)

Churches were very important to most Napans throughout the 19th and most of the 20th century, and continue to remain central to the lives of many in the community today. Pioneer Nathan Coombs was an early contributor to the Methodist Episcopal Church, seen here, which stood on Fifth and Division Streets. He also helped in the formation of the Presbyterian church, as did George Goodman and Chancellor Hartson.

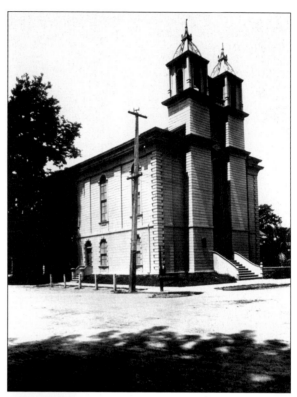

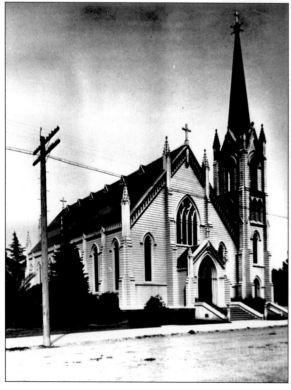

With the rapid increase in Napa's Italian population around the turn of the 20th century, the Catholic parish outgrew its building on Main Street, but it was decades before St. John's erected its new church.

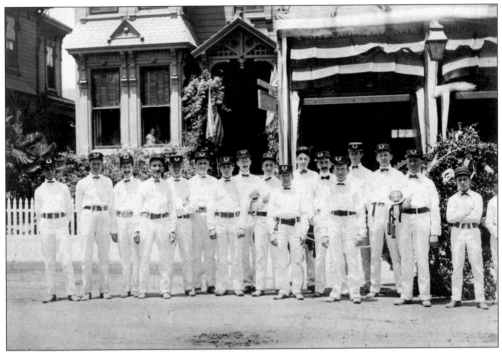

With neither television nor computers to draw them into the cocoons of their own homes, turn-of-the-20th-century residents of small cities like Napa entertained themselves with community activities. The Unity Hose volunteer fire department was big on public spirit. They entered their own band (seen here) in parades and hosted "Grand Balls," masquerade parties, and other activities.

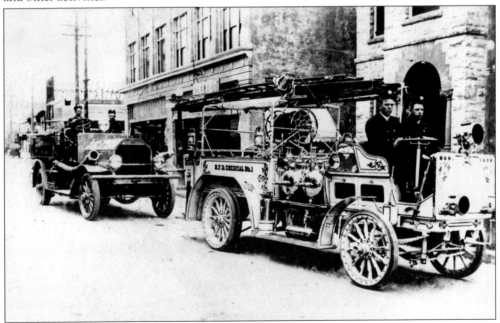

Napa's volunteer fire departments combined after the 1906 earthquake to become the Napa Fire Department. Here, NFD trucks pause in front of the Goodman Building.

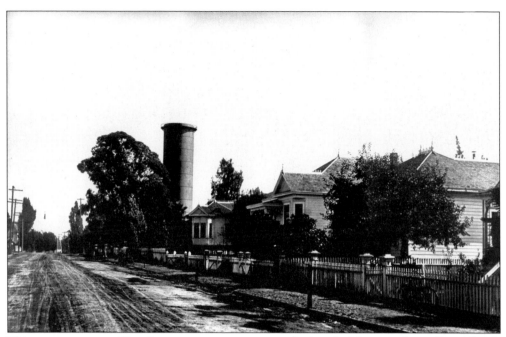

This water tower on Pine Street was a major storage facility for Napa residents. City officials worried about the chronic need for water. Many residents had private wells, but these were subject to contamination.

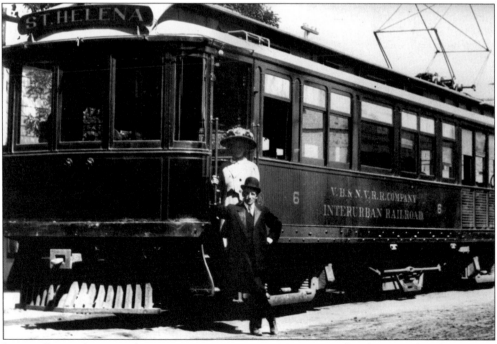

In an effort to bring vitality to a sagging economy, Napa city officials granted a charter to a developer of electric railroads shortly after the turn of the 20th century. Mainly a passenger line, the Vallejo, Benicia, and Napa Valley Railroad did quite well until the automobile and two bad crashes ended its viability.

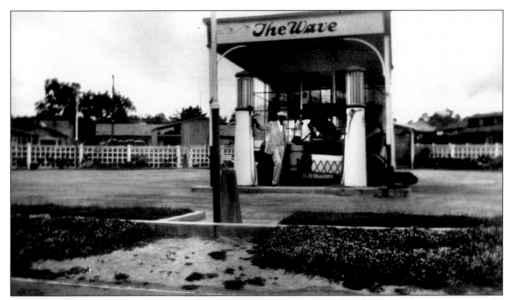

Cars and trucks did to railroads what railroads did to ferries. While neither were entirely eliminated, they ceased to be the money-makers they had once been. Drivers could watch the red-tinted gasoline bubble in the glass atop old-fashioned tanks like those at "The Wave" in Napa.

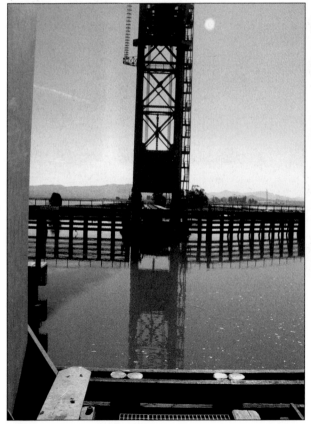

Frozen in the "up" position, this railroad drawbridge over the Napa River hasn't been used in more than a decade. Owls, gulls, and other birds nest here, their calls echoing strangely in the metal works.

Six
EASTSIDE, WESTSIDE

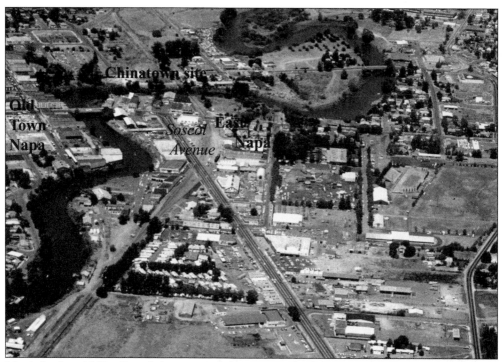

Until the late 1960s, Soscol Avenue ended just past Third Street and did not cross the Napa River. The acute double river bend is called the "ox bow" for its resemblance to a yoke. The much smaller extension of the river to the northwest is Napa Creek. Napa's very small Chinatown hugged the sandy stretch of land east of First and Second Streets, where the Napa River turns fresh and takes the sharp right turn. At the intersection of Napa Creek and the Napa River, Chinatown was prone to flooding.

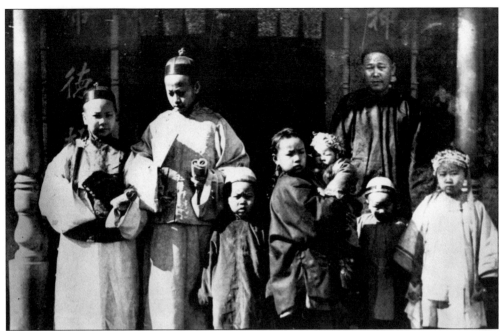

Napa's Chinatown had a Buddhist temple, or joss house. The Shuck Chan family is standing at its entrance in this turn-of-the-century picture, on what is now China Beach.

Young men are studying at the entrance to this building, which might be a Chinese family's home. Many of Napa's Asian families worked in the households of other Napans. The largest Napa Valley Chinatown was in St. Helena, where many of the men worked as day laborers, helping to construct the stone wineries, fences, bridges, and homes that proliferated Up Valley until the Chinese Exclusion Act of the 1880s.

Fire Chief Charles Otterson (left) was a good friend to the Asian community. Otterson also served as police chief for several years.

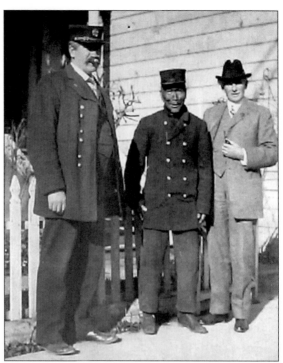

By 1930 only seven families were living in Napa's Chinatown. Mayor Charles Trower commissioned a "Napa River Club" to clean up the banks of the then atrociously polluted river, and the committee's first act was to move the seven families, at the city's expense. Thus Chinatown came to an end. Since that time, the banks have eroded. China Beach is, in essence, slowly melting away. Napa Creek (left) converges with the Napa River at this point. The small stone bridge on the left side of the picture is a younger version of the historic one running beneath Main Street and was built in 1862. It was removed in 2004.

After an apparently successful stint in the gold country, Dominic Cavagnaro, a northern Italian, brought his family to East Napa. He died of pneumonia, leaving behind a wife and two small boys. Six generations of Cavagnaros have made Napa their home. At one minute past midnight on April 7, 1932—the instant that Prohibition ended—the first truckload of beer left for Napa from a San Francisco warehouse with Dominic's grandson Ray at the helm. He sold the beer straight from the truck. The Cavagnaro's El Ray Distributors brought liquor and Budweiser beer to thirsty northern Californians for the rest of the 20th century.

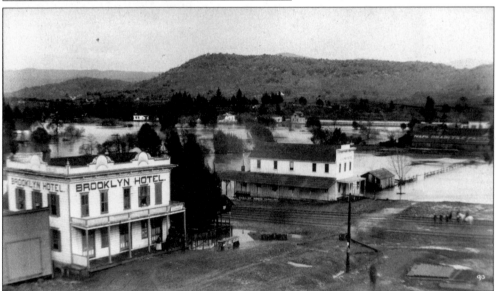

When the 1906 earthquake destroyed the North Beach neighborhood of San Francisco, which was home to many Italians, Dave Cavagnaro invited refugees to stay at his Brooklyn Hotel (later called "Dave's Place"). Many of them remained in Napa and became important members of the community. Mark Strong took this picture from the Palace Hotel during the 1890 flood. The Colombo Hotel is to the right of the Brooklyn, and beyond that the Napa Drain Tile factory. Napa Drain Tile was another major polluter of the Napa River.

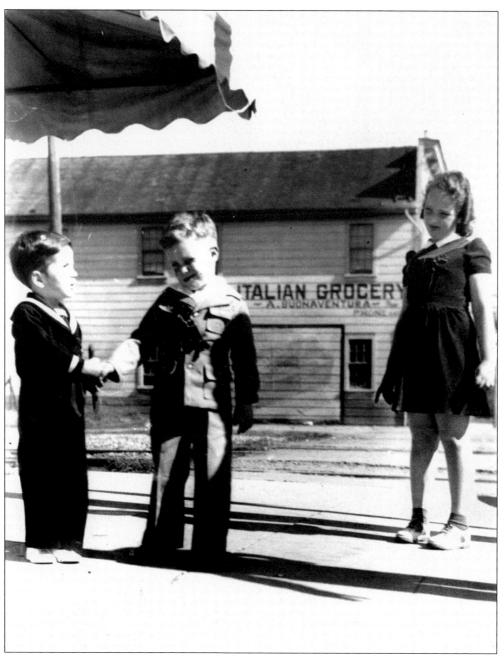

Italian immigrants replaced Asians as laborers in the Napa Valley. Newcomers fresh off the boat gathered in East Napa, where they could get jobs, cheap rooms, and all the food they could eat. Frugal and hardworking, many used their wages to buy land. Their descendants have benefited, as the value of Napa land has increased exponentially. The Buonaventura Grocery in the background (formerly the Colombo Hotel) continued to give Italians a taste of the Old Country well into World War II. The children here are Peter Paine, Dick Cavagnaro, and the future Joy Tamburelli. Paine's grandfather, Peter Molo, had a flower stand. (Courtesy of the Cavagnaro family.)

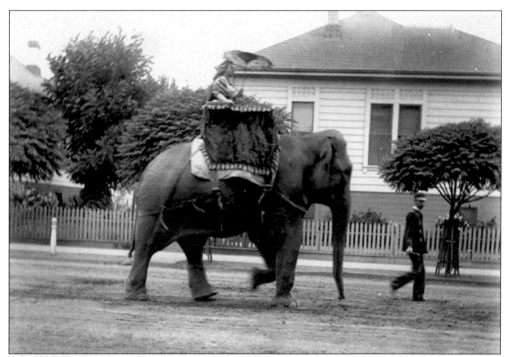

When U.S. Treasury agents began making life hard for those wishing to circumvent Prohibition laws, Dave Cavagnaro chose to join the circus and leave town. Later he returned and brought the circus with him. (Courtesy of John York.)

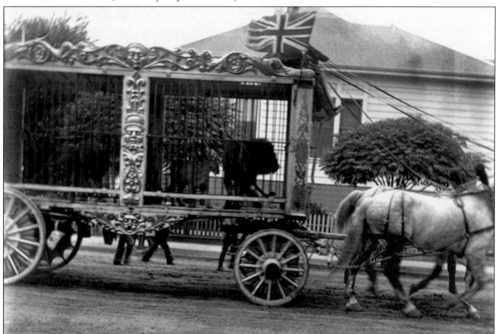

Beginning in the late 1920s, major circus companies made regular stops in Napa. A circus lion got loose during a parade one year and briefly terrorized East Napa until it was captured at George Blaufuss's Saxon Cider Company on Soscol Avenue. (Courtesy of John York.)

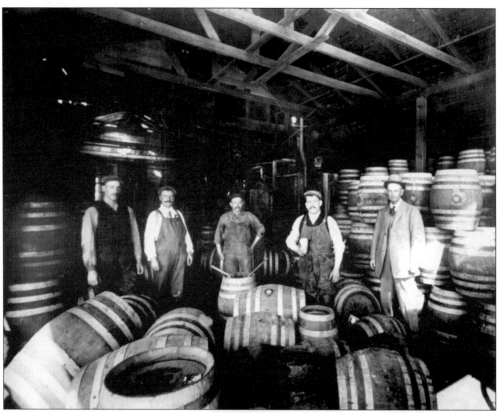

Blaufuss's Saxon Cider Company had been a brewery before Prohibition. Owner George Blaufuss brewed beer during Prohibition, too, hoping to take advantage of a loophole saying doctors could prescribe alcoholic beverages for medicinal purposes. Local law enforcement looked the other way, but the feds didn't. Judge Percy King gave him a tiny fine.

Superior Court Judge Percy King (shown here), a second-generation Napan, reigned over the Napa courts throughout Prohibition, the Great Depression, and World War II. Jack Steckter was sheriff for about the same time.

89

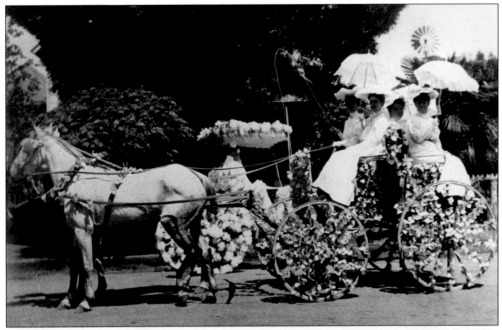

The ladies in this patriotically trimmed buggy are ready for a parade. Napa parades usually began and ended at the fairgrounds on Third Street.

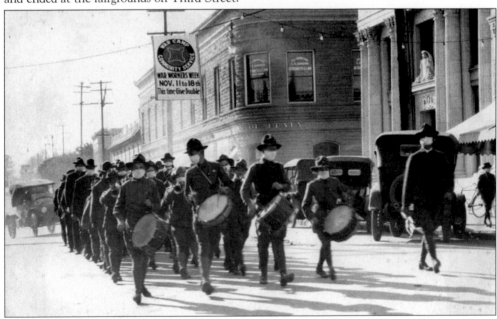

The Boy Scouts in this May 30, 1918 Memorial Day parade are wearing masks because Napa, like the rest of the world, had been stricken by the influenza epidemic. The parade ended at Tulocay Cemetery in East Napa, where flowers were placed on graves—an especially poignant gesture, because Napa lost many to the flu. In this photograph, the Bank of Italy has taken over the Goodman Bank in the Migliavacca Building, and the parade is passing in front of the First National Bank of Napa. There are relatively few onlookers because people were afraid of catching the disease. Some may have watched from their cars.

Local leaders clown around at a Prohibition-era outing. Note the open bottle in the lower portion of the picture. (Courtesy of John York.)

The Mondavi family made possible a major transformation of First Street in East Napa. Copia, the American center for wine, food, and the arts, celebrates American achievements in winemaking, cuisine, and related arts.

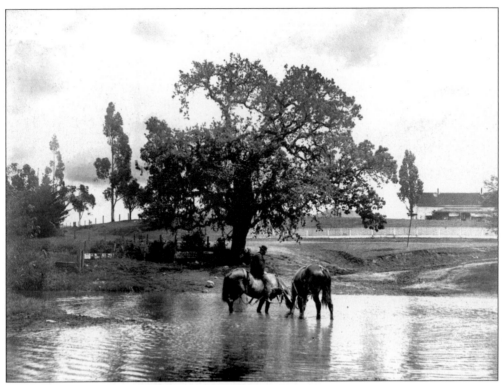

Trancas is the Spanish word for "crossing," and there were two of these well to the north of Napa. This is the smaller one, the ford over Milliken Creek, which seems to be in flood stage. The road veers to the left of the oak tree and heads up to the town of Monticello in Berryessa Valley. (Courtesy of Robert Northrop.)

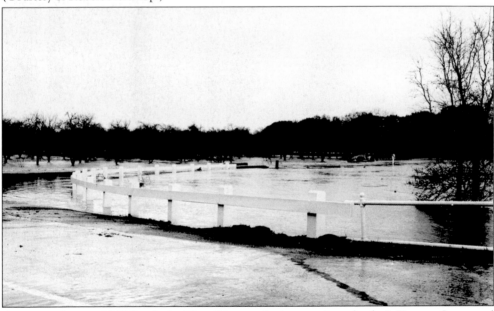

A storm in January 1940 floods the Napa River at the intersection of today's Trancas Street and Monticello Road. (Courtesy of Robert Northrop.)

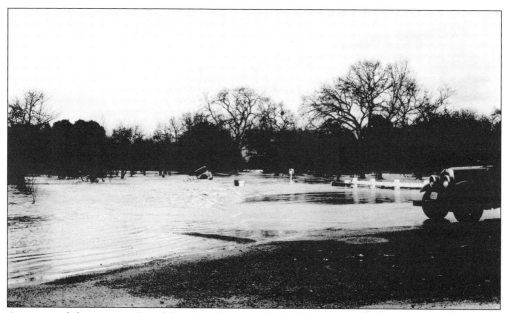

An automobile is a casualty of the 1940 Trancas flood. (Courtesy of Robert Northrop.)

With Mount George and the eastern hills in the background, this woman and her horse pose for photographer Mark Strong, who seems to have clambered up the slope among the madrones. The road was barely passable in the winter. Today, grapevines carpet the hillsides in rural Napa areas like this.

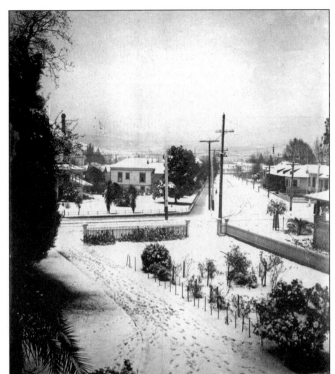

A snowstorm blankets Calistoga Avenue in 1906. West of the downtown district, this street became the main north-south artery leading to the cities in Up Valley. (Courtesy of Robert Northrop.)

A similar photograph, taken several years later, reveals that the trees in the neighbor's front yard have flourished. Much of the fencing is gone, replaced in some cases by rose trees. (Courtesy of Robert Northrop.)

A little girl, three French dolls, and a teddy bear enjoy an afternoon in a west Napa backyard. (Courtesy of Robert Northrop.)

Real candles spaced far apart and upright amongst the popcorn garlands fascinate this young boy on Christmas. The toys beneath the tree are not wrapped.

The land west of Napa was slow to develop. Brown's Valley Road, seen above and at left, was a country lane in the 1890s and remained that way well into the 20th century. Prune orchards like these along Brown's Valley Road abounded in Napa. (Courtesy of Robert Northrop.)

A father and son admire the view from a west Napa prune orchard in 1910. (Courtesy of Robert Northrop.)

The Imries, Crosbys, and Bickfords gather for a picnic among the redwoods in the hills west of Napa. (Courtesy of Robert Northrop.)

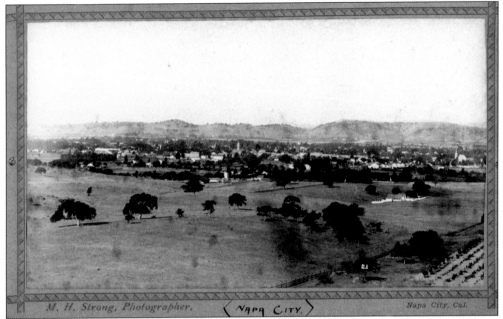

Mark Strong appears to have shot this picture from what is now the Alta Heights area. The view looks west towards the distant hills. Wood was the primary building and heating material in the 19th century, and the hills have been extensively lumbered. A grower has spread sand on his vineyard (lower right corner) in a futile attempt to discourage *phylloxera*, a small insect that nearly destroyed the wine industry. The bulbous cupola of the courthouse is directly in the center of the picture. The Palace Hotel, with its many windows, and the Noyes Lumber Company at the foot of the Third Street Bridge are visible, with the Brooklyn Hotel between them.

Napa has been so successful in encouraging the planting of trees that it is an official "Tree City USA" community, with a publicly funded tree-advisory commission. The City of Napa is in the center of the picture. The diagonal swath near the center is the eastern part of First Street, dominated by Copia. Third Street is to the left, with its large county administration buildings. This picture was taken in 2004 from the Beardsley residence atop Montecito Boulevard.

Seven

SOUTH OF NAPA

The area south of Napa City and east of the river, although flat and prone to flooding, was good grazing land. A few businesses sprouted up on the stretch between Napa City and the state hospital. The Gasser family invested in this largely unimproved acreage, guessing (correctly) that someday this farmland would be developed. The photographer took this picture of the southern reaches of Soscol Avenue in August 1947.

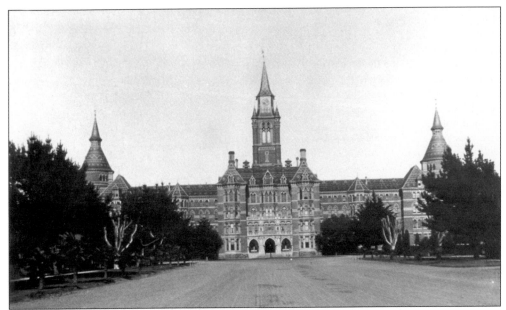

Since its creation in 1875, the Napa Insane Asylum (now Napa State Hospital) has been both a blessing and a curse for Napa. Once a major county employer, it was the first institution of its kind in California. Chancellor Hartson was instrumental in bringing it to Napa. An example of monumental Gothic architecture, the asylum used many therapeutic techniques influenced by Europe, especially Germany, which was then regarded as the intellectual center of Western medicine.

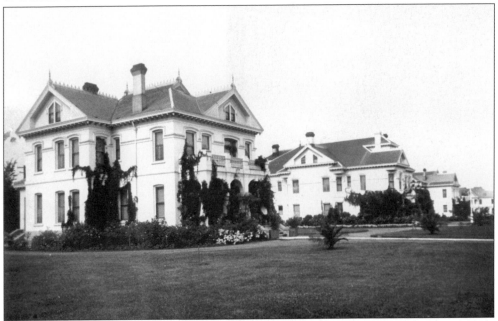

The asylum's first doctors lived in posh homes on Magnolia Drive, the facility's main access road. The hospital proved to be a mixed blessing. While it provided employment for many Napans, it was such a unique institution that its renown overshadowed Napa City's. "Going to Napa" became synonymous with being "put away."

When Jose Altimira first explored the Napa Valley in 1824, he was struck by the amount of volcanic rock in the area: "Enough," he wrote in his journal, "to build a new Rome." He might have been passing through what would become the quarry of the Basalt Rock Company. A.G. Streblow, shown here in his World War I Navy uniform, began quarrying the dense, fine-grained volcanic material in 1924. Streblow and his vice president, Ed Brovelli, used the profits they made selling crushed rock to purchase other quarries and more land. By the 1930s, they were shipping rock for use in the construction of the Golden Gate Bridge, the Bay Bridge, Hamilton Air Force Base, and other major projects. To facilitate transport, they purchased land on the Napa River and built their own barges. (Courtesy of the Basalt Corporation.)

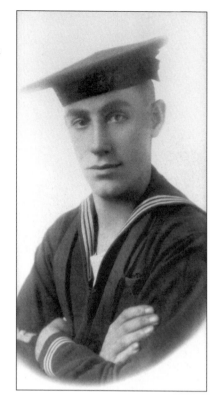

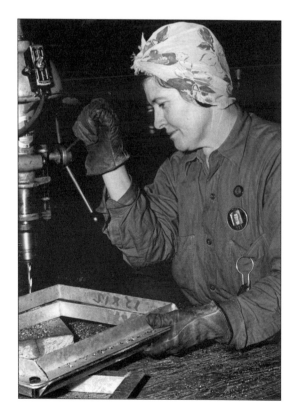

Women went to work throughout America during World War II. This Basalt employee operates a drill press in a sheet metal shop. (Courtesy of the Basalt Corporation.)

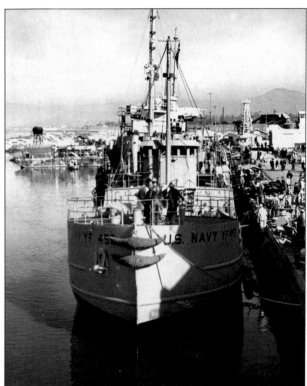

During World War II, Basalt converted its barge-building facility into a shipbuilding plant. The company built and launched U.S. Navy vessels like YF 452 and repaired battle damage done to others. Their work earned them the prestigious "Navy E." (Courtesy of the Basalt Corporation.)

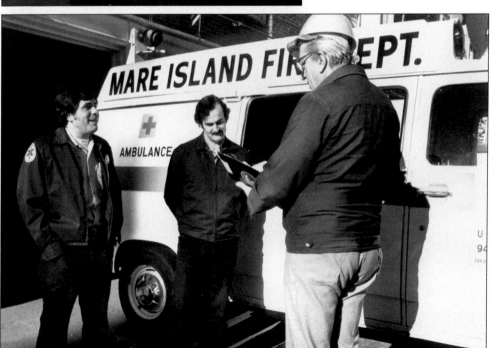

Vallejo's Mare Island Naval Shipyard, 12 miles south of the Basalt plant, was Napa's major employer before, during, and for a long time after World War II. Warrant Officer Harry Gray (right), a Napan, takes care of business in this U.S. Navy photo. (Courtesy of Carol Lawler.)

Another official U.S. Navy photo shows Napan Jack Mast, then an apprentice blacksmith, at Mare Island.

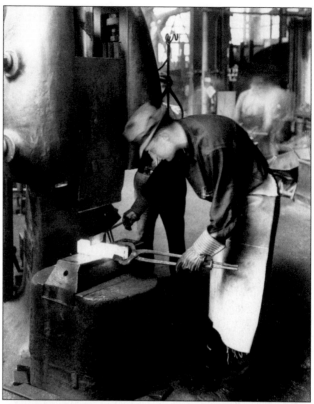

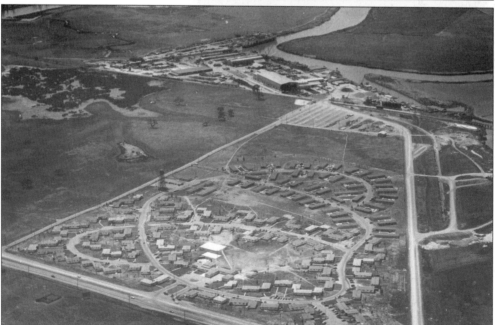

World War II brought an unprecedented population explosion to the Bay Area. The Napa Housing Authority developed Shipyard Acres, adjacent to the Basalt Company's Napa River plant, to relieve the shortage of homes. (Courtesy of the Basalt Corporation.)

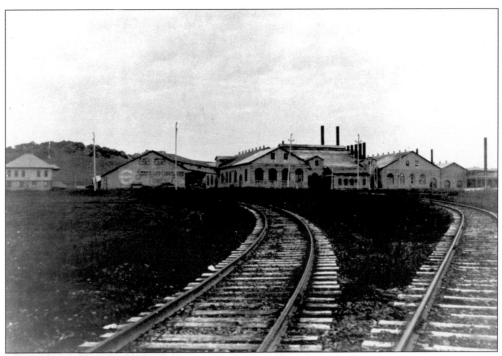

The Standard Portland Cement Company had a busy processing plant in the South County, conveniently located near a confluence of train tracks that was itself a tiny town known as Napa Junction.

After the completion of Interstate 80, American Canyon Road became an important link for commuters. New residents tended to gather near the American Canyon/Highway 29 intersection, and Napa Junction, never a vigorous population center, diminished in importance. American Canyon incorporated as a city in 1994 and is now the fastest-growing community in Napa County. Recent estimates predict that more than 10,000 people will call it home by 2010. Neat and tidy, this new mall offers American Canyon residents new choices.

Eight
AGRIBUSINESS

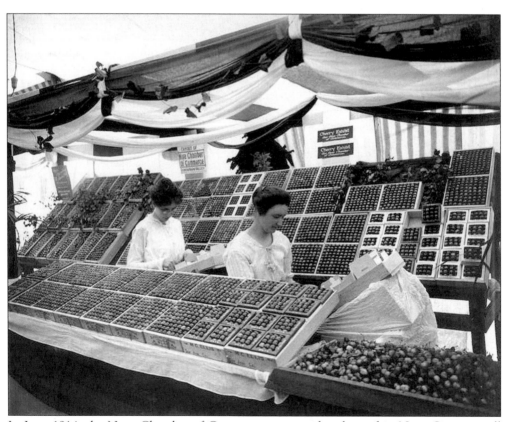

In June 1914, the Napa Chamber of Commerce sponsored a cherry fair. Napa City was still surrounded by orchards as late as the 1960s, and many Napa baby boomers remember spending summer weekends picking fruit.

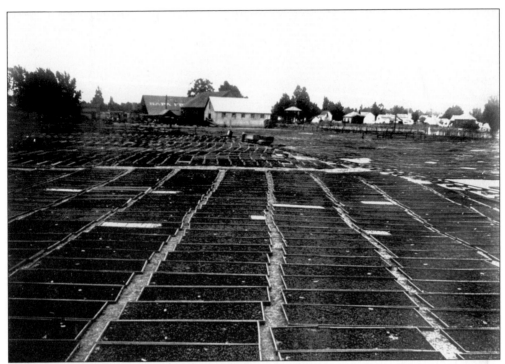

Prunes, not grapes, were once the dominant fruit in the Napa area. The profit margin was slim though. Drying them cost money, took time, and increased the economic risk, because a heavy rain after harvest would ruin the crop. Prune dehydrators were located throughout the valley, but many dry yards, like the one shown above, just used the sun.

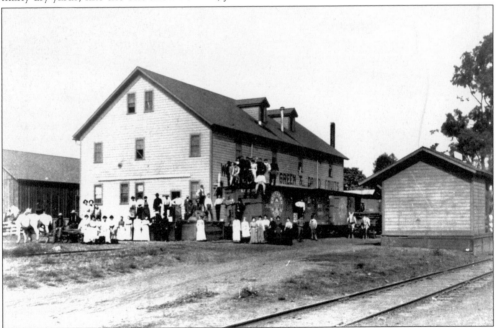

William Fisher's drying and packing plant had its own depot north of town. Women wore long dresses, even when working in the field.

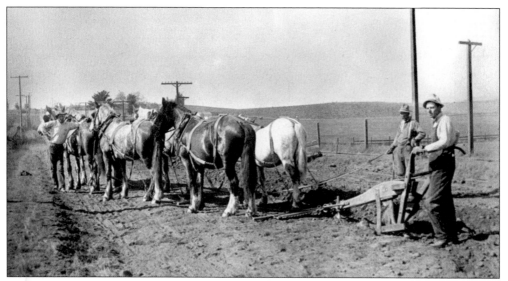

Men and horses worked the soil together before the advent of mechanized tractors. Farming was a team effort that usually involved several members of the family.

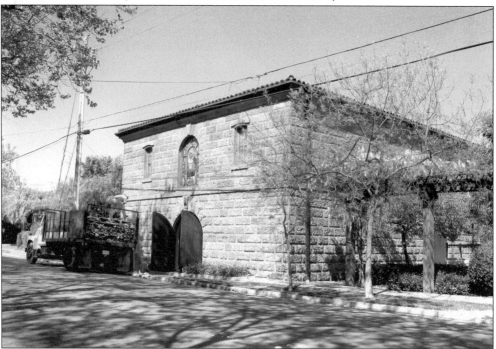

Farmers in the Napa City area engaged in viticulture in the 19th century, although not nearly to the extent that Up Valley growers did. One of Napa's earliest vintners was Jose Mateus, a Portuguese man whose name was anglicized to Joseph Matthews. In 1881, Bostonian Lloyd Vernon Briggs visited Mateus's Lisbon Winery, which was located on Brown Street. Bottles of sherry and port sold for 50¢ each, he said, and Mateus distilled his own whiskey, which sold for $1 a bottle. "He wanted us to taste almost everything," Briggs wrote in his book, *California and the West, 1881, and Later*. "He is too generous for us to go there often!" Here, workers repair flood damage to the old building, which is now the Jarvis Conservatory.

Attorney Morris Estee was the first president of the Napa Viticultural Society when it formed in 1881. He planted some 600 acres in the Napa Valley, about half in grapevines, and in 1882 ran unsuccessfully as the Republican candidate for governor. His winery, which he called "Hedgeside," currently houses the wines of Del Dotto Vineyards. Estee also had a distillery, which he used to make brandy. According to law, distilleries had to be a specified number of yards from wineries. Estee's old distillery is now the Jessel Art Gallery.

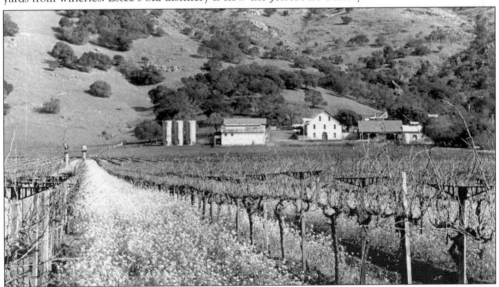

Terrell Grigsby, a nephew of Bear Flagger John Grigsby, built a winery in 1878 using Chinese laborers. Anti-Asian prejudice was high at the time; arsonists who objected to his hiring practices burned the winery down and threatened other fires if Grigsby continued hiring them. He rebuilt and renamed his winery "Occidental." It eventually folded, and the land was used for pasture. In 1932, Gaetano Regusci bought the building and the acreage. The Reguscis made wine for their own consumption but used most of the land for general agricultural purposes until 1995, when they reestablished a winery there.

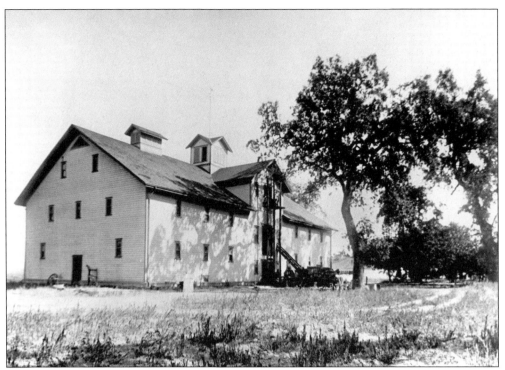

The Goodman family founded the Eshcol Winery (shown here), now Trefethen, in north Napa. The Churchills—the family of George Goodman's daughter—also had a winery, To-Kalon, located north of Yountville.

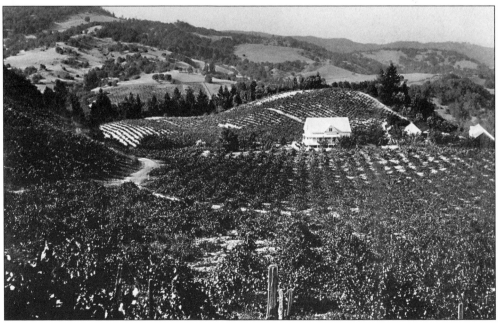

Phylloxera, a tiny root louse, had gobbled up much of the wine industry by the turn of the century. Growers like the one on this west Napa hillside spread sand in their vineyards in an effort to kill the pest. Unfortunately it didn't work. (Courtesy of Napa Redwood Estates.)

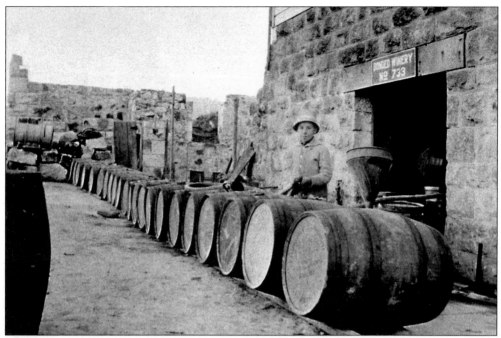

Prohibition went into effect on January 17, 1920, ending the wine industry until the law was repealed 12 years later. This picture, taken at Castle Rock Winery in 1920, appears to show barrels being filled . . . perhaps on January 16? (Courtesy of Napa Redwood Estates.)

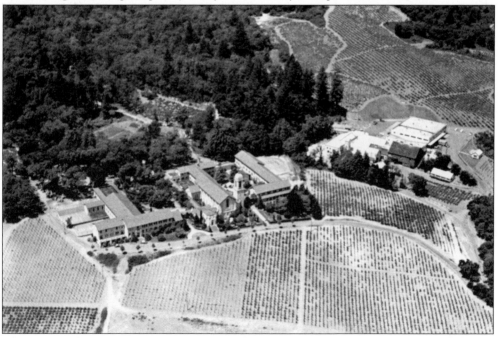

Christian Brothers was a major California winery from the 1950s through the 1980s. Their Mt. La Salle Vineyard in Napa was still young when this photo was taken in 1952. Vintner Theodore Geir was the previous owner of the land. He was arrested and jailed for violating Prohibition laws in the early 1920s.

Larry Hyde of Hyde Family Vineyards in Napa's Carneros District employs organic farming on some of his 182 acres. He was one of the first growers since Prohibition to farm wine grapes in the South County. (Photo by Priscilla Upton, courtesy of the Wine Library Association.)

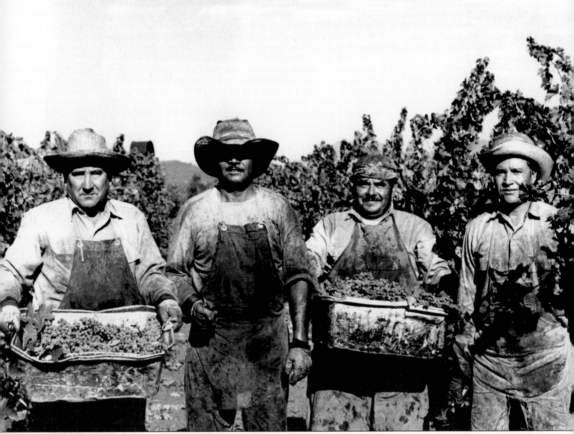

Migrant Mexican workers now harvest most of the vineyards in the Napa Valley. Difficult, back-straining labor, it is usually undertaken in the hot sun. Although California once belonged to Spain and Mexico, there were few Hispanics in the Napa area before the 1970s. Now they are the largest-growing ethnic group in the Napa Valley, much as the Italians were a century earlier.

Nine
NEIGHBORS TRANSFORMED

Nowhere have the currents of change been more dramatic than in the Berryessa Valley, which consisted of 35,315.82 acres granted by Mariano Vallejo to two brothers, Jose Jesus and Sisto Berryessa. Putah Creek (actually a small river) ran through the center of the valley, highlighted here beneath ominous clouds. Berryessa's hot, dry climate and deep, rich soil differed from that of the Napa Valley. (Courtesy of Janice McKenzie.)

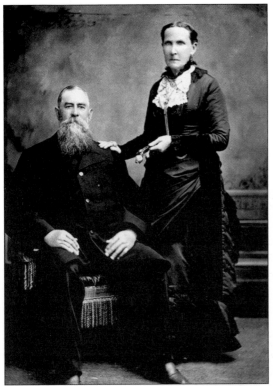

Farmers squatted in Berryessa Valley (meaning they lived on and used the land without title to it) until 1866, when it was surveyed and divided for sale. Arriving in Napa County almost penniless that year, Abraham Clark eventually owned legal title to much of the valley. He was a Democrat, a teetotaler, and patriarch of a large clan. Many of his children remained in Berryessa Valley and raised families of their own. Beside him is his wife, Electa. (Courtesy of Janice McKenzie.)

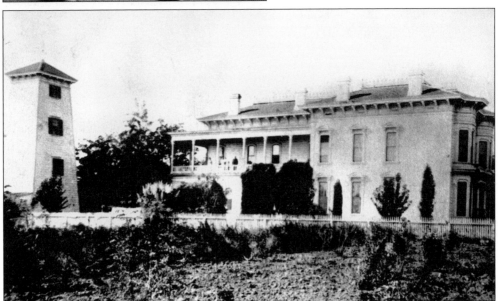

The Clarks built a mansion, "The Adobe," on what had been the site of a squatter's house. The Clark mansion had 22 rooms and one indoor bathroom—a luxury in its day. The family could communicate with their Chinese cook through a speaking tube that led from the third floor to the kitchen. The Adobe caught fire in 1926 and took many hours to succumb to the flames. The family had time to remove most of their valuables. It wouldn't be the last time disaster hit the McKenzie clan. (Courtesy of Janice McKenzie.)

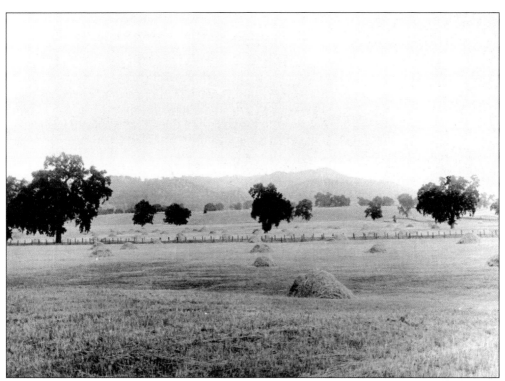

Other farmers also planted wheat—thousands of acres of it. Majestic Valley oaks dotted the landscape, looking, amidst the waving grain, like ships at sea.

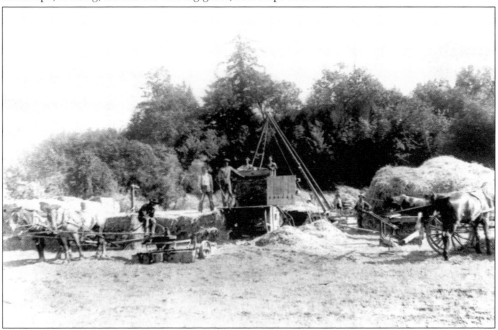

The year revolved around the planting, harvesting, and threshing of wheat. It took three days for a mule team to haul the wheat down 27 miles of winding road to Napa and back. Wagons could hold about 110 sacks, or around seven tons.

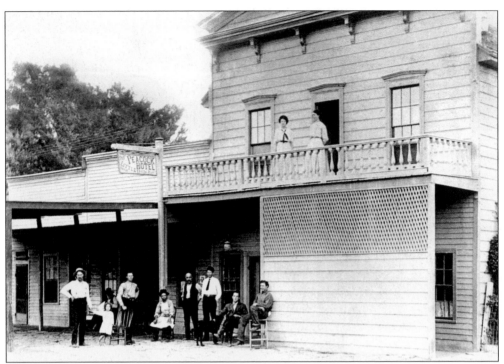

Like Abraham Clark, Ezra A. Peacock came to Berryessa Valley in 1866. His home became a hotel, which grew to include a bar and a livery stable. Stages and wagons en route from Sacramento to the quicksilver mines in Knoxville and Pope Valley would often change horses at the Peacock. The Little brothers took over the hotel around 1900. Wade Little (white shirt and tie) stands between Wassum, the blacksmith (left), and Joe Moore, who would be sheriff of Napa County at the start of Prohibition. To the left of Wassum is a Chinese cook. Many farms employed Asians in their households. (Courtesy of the Bureau of Reclamation.)

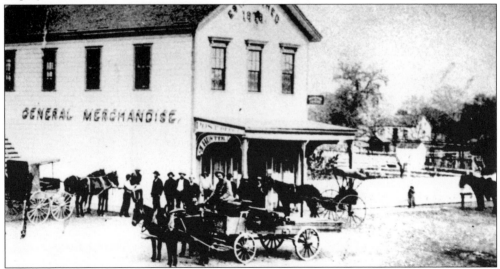

A man named Hunter established a general store and post office in Monticello in 1878. The second floor was used as a community meeting hall and social center. (Courtesy of Janice McKenzie.)

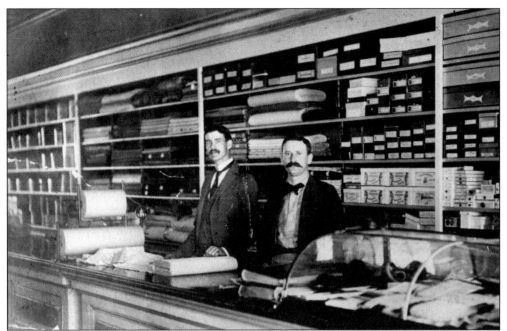

William David McKenzie (left) and William C. Cook founded Cook & McKenzie in 1893. By World War I, Monticello had two general stores, a Chinese laundry, two blacksmith shops, a Methodist church, a cobbler, a constable, a carpenter, a saloon, and a jail. A retired doctor lived in the general vicinity, and there were two elementary schools, one in town and one in a place called Oak Grove. There was also a golf course, Sugarloaf, which used sand for its greens because there wasn't enough water to maintain grass. (Courtesy of Janice McKenzie.)

Cook McKenzie & Son was Monticello's commercial hub in the mid-20th century. The "Son" was another McKenzie. (Courtesy of Janice McKenzie.)

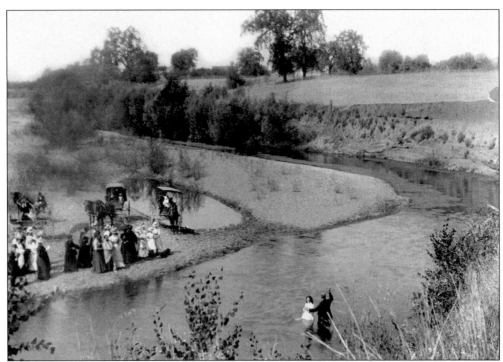

Going to church was a community activity, and many Monticellans were staunch Prohibitionists. Here, the photographer has recorded a full-immersion baptism in the waters of Putah Creek. (Courtesy of the Bureau of Reclamation.)

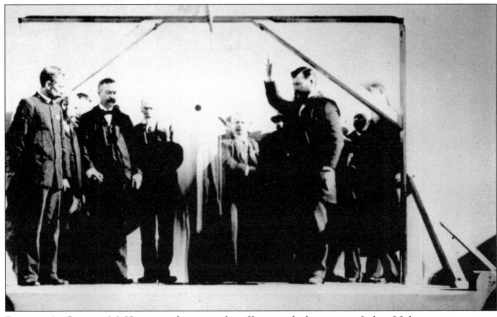

Berryessa's George McKenzie, who was sheriff around the turn of the 20th century, raises his hand as he officiates over the last legal hanging in Napa County. The doomed outlaw is barely visible, already ghostly as he drops at center, too fast to be captured on film. (Courtesy of Janice McKenzie.)

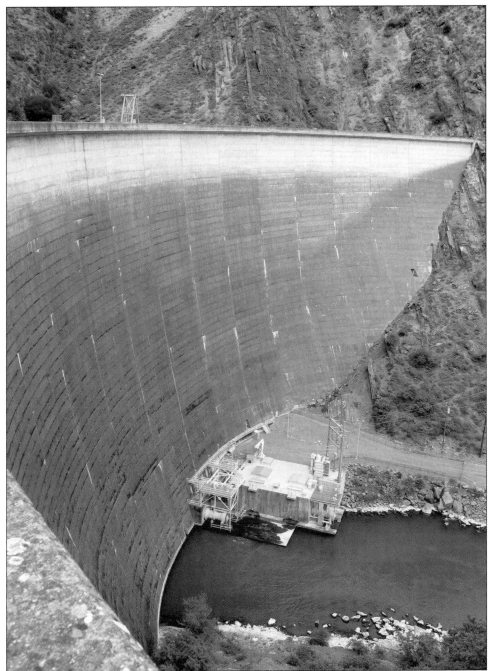

Unbeknownst to the hanging party on the previous page, Berryessa itself was also doomed. A narrow mountain pass at the end of the valley known as Devil's Gate provided a natural setting for a hydroelectric dam. The population explosion in neighboring Solano and Yolo Counties and the development of farming there created a critical need for water. Putah Creek contributed to winter floods that imperiled the Sacramento River basin; containing it seemed like a good idea for all of those reasons. But damming the creek meant slowly drowning Berryessa Valley and destroying the little town of Monticello.

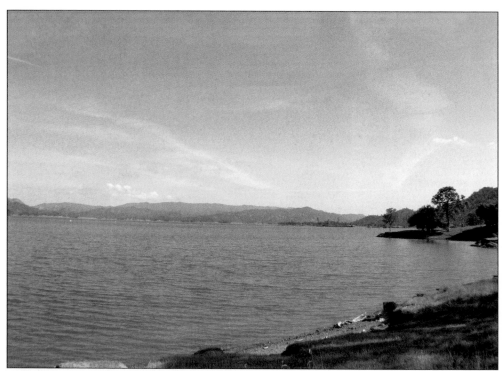

Lake Berryessa is now a well-maintained recreational area that offers boating and swimming as well as excellent fishing. Many long-time Napans, however, still feel uncomfortable about visiting the lake. As one old-timer put it, "too many ghosts." (Courtesy of the Bureau of Reclamation.)

Many of Napa County's pioneers began as farmers. A.G. Clark and his family (no relation to Abraham Clark of Berryessa), for example, came west on a wagon train in 1850. By the time they put down roots in what is now the town of Yountville, the Clarks had survived cholera, near starvation, a shipwreck, and attack by hostile Indians. Their farm proved not only restorative but profitable. They eventually moved to Napa City, where A.G. opened a successful hardware store. The Yountville Veterans Home, established in 1882, is located on the site of Clark's old farm, as is the Napa Valley Museum.

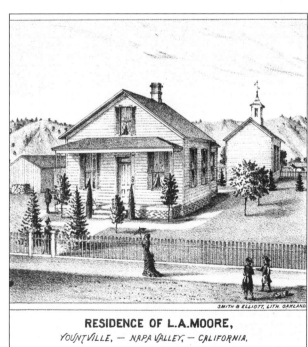

RESIDENCE OF L.A. MOORE,
YOUNTVILLE, — NAPA VALLEY, — CALIFORNIA.

Yountville was a tiny farming community of about 150 people before the Veterans Home arrived in 1884. L. Moore was the stationmaster at the depot but also owned a soap factory and sold lumber. In 1881, the business district of Yountville consisted of one general store, one saloon (many of the residents were Baptists), two hotels, two blacksmiths, a tin shop, and two "shoe shops" (for horses, perhaps). After 1884, the number of saloons increased sharply.

This photo of Yount Hill was taken in the early 1960s. Vineyards surrounded the town of Yountville even then, but luxury bed-and-breakfasts and pricey restaurants were a thing of the future. (Courtesy of the Town of Yountville.)

Gottleib Groezinger built a very large brick winery in Yountville in 1870 on property he bought from a member of the Boggs family. Groezinger's wine was sold as far away as London, but the company operated for less than 20 years before succumbing to the economic downturn of the 1890s. Like Morris Estee's Hedgeside, Groezinger's may have made sherry and/or brandy as well as wine, as there are two associated buildings on the property. Another vintner, Alois Finke, was associated with Groezinger's in the 1890s. "A. Finke's Widow" made a dessert wine, Madeira, apparently after Finke's death. In the 1970s, the Groezinger complex was transformed into Vintage 1870, a complex of boutique shops that has been more successful than the original winery ever was.

Elderly gents who fought in the Mexican-American War and for the Union in the Civil War could work the farm at the Veterans Home or, if they preferred, hang out and do nothing. Many did the latter in the numerous saloons that sprang up in Yountville to serve them.

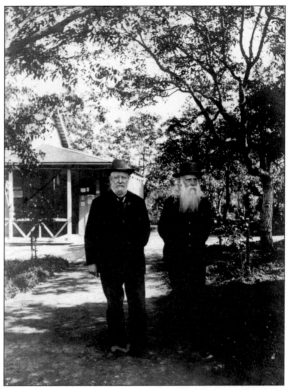

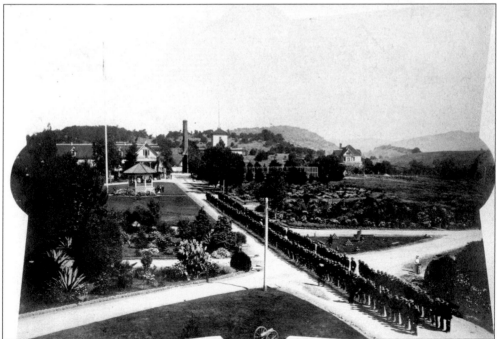

Veterans of the Spanish-American War soon joined those of the Civil and Mexican-American Wars. The Veterans Home surpassed its planned capacity in a few short years and underwent several expansions.

Meals were 5¢ at the Magnolia Hotel in downtown Yountville, according to the faded advertisement on the side of this building. This 1950s picture reveals that the old structure was ready to crumble; it has since been restored. The Magnolia Hotel is now the French Laundry, acclaimed by many as the best restaurant on "planet earth." The cost of a meal there today will definitely exceed the original 5¢. (Courtesy of the Town of Yountville.)

An artist captured these Yountville relics before they were destroyed or upgraded to make way for today's Beard Plaza. The Veterans Pool Hall burned down in 1959, the dance hall was razed, and the saloon has been "restored" to lend it greater dignity than it ever knew before, as shown in the photo below. The transition of Yountville's rundown saloons to upscale small businesses is stunning. (Courtesy of the Town of Yountville.)

This building has housed a variety of businesses in its long life, including Gibbs' Saloon, and its walls would speak volumes if they could talk. Many of Yountville's old saloons offered female companionship for a small fee. Oddly, citizens appeared to be angrier about the use of alcohol at these places than the other temptations offered there. The building currently houses a fashionable restaurant.

Time has damaged this picture of Peter Gillam and his wife, who owned much of what is now the town of Yountville. On the other hand, time has done wonders for the town itself. The city that once had the lowest per capita income in California (due to the indigent population at the Veterans Home) is now a Napa Valley jewel. (Courtesy of the Town of Yountville.)

Algerian restaurateur Claude Rouas established Piatti Restaurant in 1981 to provide a greater variety of culinary choices for guests at his Auberge de Soleil resort. Since that time so many fine restaurants have come to Yountville that the little town has more top-notch eateries per capita than any other place in California.

Napan Don Carr, seen here with his wife, Lonne, was chairman of the Lincoln Theater Renovation Committee. The Carrs are among several Napa Valley families who contribute time, talent, and treasure to create fine cultural venues like the new, state-of-the-art Lincoln Theater in Yountville, the Napa Opera House, Copia, and the Napa Valley Museum.

The Friends of the Lincoln Theater have worked for eleven years to transform the auditorium at the Veterans Home into a major performance center with seating capacity for 1,200.

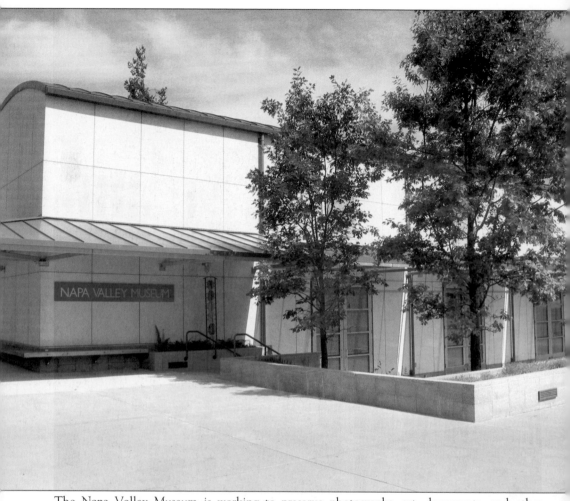

The Napa Valley Museum is working to preserve photographs, art, documents, and other artifacts of regional historical significance so that they can be seen and enjoyed by everyone. The museum is located at 55 Presidents Circle in Yountville, near the Veterans' Home.